ARTISTS OF LA REVUE BLANCHE

ARTISTS OF LA REVUE BLANCHE

ARTISTS OF LA REVUE BLANCHE

BONNARD · TOULOUSE-LAUTREC · VALLOTTON · VUILLARD

ESSAYS BY

BRET WALLER

GRACE SEIBERLING

MEMORIAL ART GALLERY

OF THE UNIVERSITY OF ROCHESTER

JANUARY 22–APRIL 15, 1984

ROCHESTER, NEW YORK

Artists of La Revue Blanche
Exhibition organized by Bret Waller
Catalogue designed by Sandra Ticen

The exhibition and catalogue have been made possible by
grants from The National Endowment for the Arts Museum
Program and the New York State Council on the Arts Museum
Aid Program

The catalogue is printed in an edition of 2,000 by Canfield &
Tack, Inc., Rochester, New York and color separations by LCC
Graphics, Tonawanda, New York on 100 lb. Lustro Dull;
typesetting in Pasquale Light by Rochester Mono/Headliners,
Rochester, New York.

Front cover:

Pierre Bonnard (1867–1947)
La Revue Blanche, 1894
lithographic poster
Bouvet 30
31⅜ x 24⁵⁄₁₆ in. (797 x 618mm)
The University of Michigan Museum of Art

CONTENTS

6 Foreword

7 Lenders to the Exhibition

9 *La Revue Blanche* Bret Waller

15 Artists and the *Revue Blanche* Bret Waller

27 The Artists of the *Revue Blanche*
 and the 1890's Grace Seiberling

57 Catalogue

99 Selected Bibliography

FOREWORD

Art movements in our time have succeeded one another with such regularity that we now are inclined to view the entire history of art in terms of cause and effect, to perceive a chain of events stretching link-by-link from Lascaux to the latest evolutionary or revolutionary development. While this helps us discover a reassuring order underlying the apparent chaos of past events, it sometimes leads us to value artists and art movements more for what they led to than for what they, themselves, accomplished.

The four artists featured in this exhibition—Pierre Bonnard, Henri de Toulouse-Lautrec, Félix Vallotton and Edouard Vuillard—while scarcely unknown, all have suffered in some degree from this preoccupation with the "historical mainstream." Despite the fact that all four were artists of talent, even genius, they left no issue, annointed no successors, founded no schools. As a result they sometimes receive less attention in textbook histories of modern art than the quality of their work warrants.

The present exhibition views the past through a microscope rather than a telescope. It focuses on a single remarkable institution—*La Revue Blanche*—that in the span of little more than a decade became a rallying point for the creators of the best avant garde art, literature, theatre and music of its time.

The artists whose work is featured here were chosen not only because they were the four most intimately and consistently associated with the review throughout its existence, but because their work partakes more fully than that of any of their colleagues of what Julien Benda called "*L'Esprit Revue Blanche.*" "At the moment when the *Revue Blanche* occupied its suite of offices on rue Laffitte," writes J. B. Jackson, "the nearby cafés and brasseries were in full swing. . . . It was the life of Paris that constantly erupted all around the *Revue Blanche*" that kept its editors abreast of all that happened, protecting them against an excess of seriousness and infusing the review with "something of the spirit of the boulevardier." Bonnard, Lautrec, Vallotton and Vuillard, each according to his own temperament and talent, recorded different facets of the kaleidoscopic spectacle of fin-de-siécle Paris. Their shared interest in the daily realities of modern urban life set them apart from many of their contemporaries who sought inspiration in exoticism, religion, mysticism, or ancient mythology, and made these four quintessentially artists of *La Revue Blanche*.

When planning for this exhibition began more than three years ago we were aware of only two other exhibitions, both European, that had previously explored the world of *La Revue Blanche* and the artists associated with it: *Autour de La Revue Blanche* at Galerie Maeght, Paris, April–May 1966, and *Die Maler der Revue Blanche* at the Kunsthalle, Berne, Switzerland, March–April, 1951. Shortly before this catalogue went to press we learned of plans for a third *Revue Blanche* exhibition being organized for Wildenstein, New York, by M. Georges Bernier, and scheduled to open in November, 1983. It will have taken place before our exhibition opens. All three of these previous exhibitions have taken as their dramatis personae most of the artists associated in any significant degree with the *Revue Blanche*. In this respect they differ significantly from the present exhibition which focuses on only four of the more than forty artists whose work was published or reproduced at one time or another in the review.

Many people have helped make this exhibition possible, too many to acknowledge individually here, but a few deserve particular mention for their special contributions. Professor Grace Seiberling of the University of Rochester has written a perceptive catalogue essay that places the *Revue Blanche* and its artists in the context of Paris in the 1890's. Professor Seiberling also has made helpful suggestions about catalogue entries and the other two essays.

Among the lenders, three have been extraordinarily generous, as the catalogue listing makes clear: The Atlas Foundation of Washington, D.C., Mr. and Mrs. Herbert Schimmel of New York, and Mr. Alfred Ayrton. Without their generous cooperation the exhibition would have been severely diminished. They, together with their fellow lenders, have our deepest gratitude.

Others who have given valuable advice and encouragement include Georges Bernier, Richard Brettell, Jan Buerger, Joyce Hartke, Konrad Kuchel, William McGrath, Jeanne Stump and Donald Vallotton. The catalogue was designed by Sandra Ticen.

The Memorial Art Gallery staff all have provided their customary excellent support. Those especially involved with this project include Patricia Anderson, Mark Donovan, Sandra Markham and Donald Rosenthal. Betsy Stellrecht and Celeste

LENDERS

Urdahl typed the manuscript. The Women's Council through its effective committes has contributed greatly to the success of this enterprise. The Council also has funded the splendid related exhibition of French "Belle Epoque" gowns from The Metropolitan Museum of Art's Costume Institute. We are grateful to Paul Ettesvold and Judith Jerde of the Metropolitan Museum for their assistance with the installation of the gowns.

Funding for the exhibition has come from Gallery members and from the National Endowment for the Arts, the New York State Council on the Arts and the Institute for Museum Services.

Finally, I wish to acknowledge the unfailing support of my wife, Mary Lou, whose enthusiasm for this project has never wavered.

B.W.

Albright-Knox Art Gallery, Buffalo, N.Y.

Allen Memorial Art Museum, Oberlin College, Oberlin, Ohio

Art Gallery of Ontario, Toronto

Art Institute of Chicago

The Atlas Foundation

Mr. Alfred Ayrton

Baltimore Museum of Art

Cabinet des estampes, Geneva, Switzerland

Professors George and Alice Benston, University of Rochester

Denver Art Museum

Galerie Paul Vallotton, Lausanne, Switzerland

Jane Voorhees Zimmerli Art Museum, Rutgers University, New Brunswick, N.J.

Metropolitan Museum of Art, New York

Museum of Art, Carnegie Institute, Pittsburgh, Pa.

Museum of Fine Arts, Springfield, Mass.

Museum of Modern Art, New York

National Gallery of Art, Washington, D.C.

New Orleans Museum of Art

Petit Palais Musée, Geneva, Switzerland

Mr. and Mrs. Herbert D. Schimmel, New York

Smith College Museum of Art, Northampton, Mass.

Solomon R. Guggenheim Museum, New York

Syracuse University Art Collection, Syracuse, N.Y.

University of Michigan Museum of Art, Ann Arbor, Mi.

Yale University Art Gallery, New Haven, Conn.

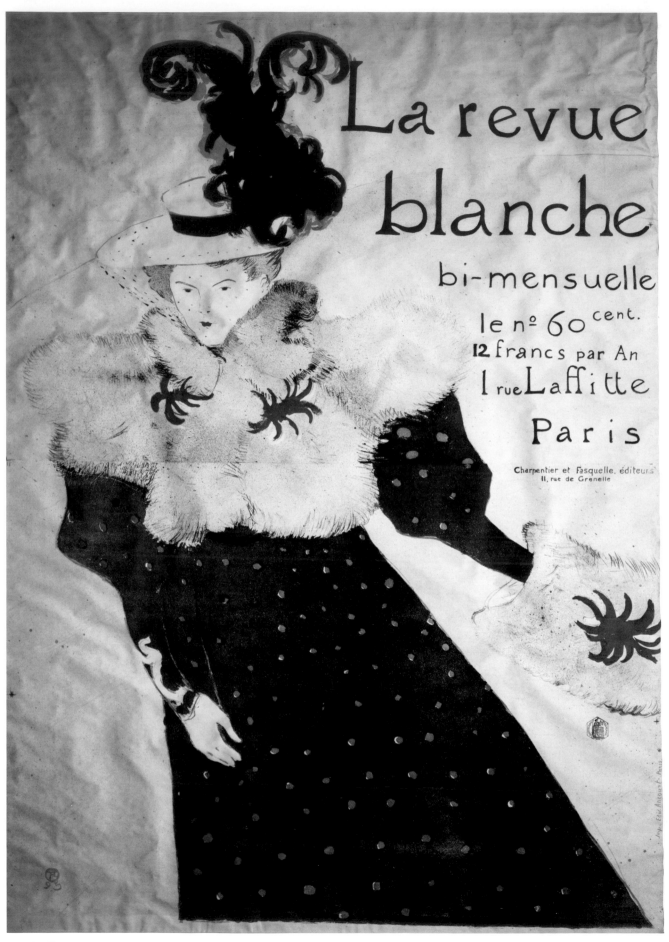

Cat. No. 40

40. **Henri de Toulouse-Lautrec (1864–1901)**
La Revue Blanche, 1895
color lithographic poster
Delteil 355
51³/₁₆ x 37³/₈ in. (1300 x 950mm)
From the collection of Mr. and Mrs. Herbert D. Schimmel

On December first, eighteen eighty-nine, a new literary journal made its debut in Paris. The new publication differed from existing reviews, most of which championed one or another of the competing literary movements of the day, in that it was to be, in the words of the introductory editorial, "open to all opinions and all schools."[1] Hence, the name *La Revue Blanche,* "white" signifying a blend of all shades of opinion just as white light is the sum of all the colors of the spectrum.

The infant *Revue Blanche,* printed in Liège, Belgium,was not prepossessing in appearance. The first issue consisted of just four pages, each about eight by ten inches, and only thirteen hundred examples were printed. The review was to be a bimonthly. "A little leaflet, appearing now and again a hundred and fifty leagues from here; four or eight pages filled up by one or two [authors]—that was us five years ago," wrote Editorial Secretary Lucien Muhlfeld in Paris in 1893.[2]

From this modest beginning grew what has been called "the best periodical of its kind that has ever been published."[3] In the course of the following decade and a half it featured work by nearly all the leading authors and critics of the day. Writings by Ibsen, Paul Claudel, Flaubert, Maeterlinck, Mallarmé, Proust, Stendahl, Strindberg, Chekov, Tolstoy and Verlaine appeared in its pages. Literature, theatre, music, art, sports and politics were regularly discussed. "The hospitable *Revue Blanche,* open to all comers,"[4] was Mallarmé's description.

Although initially printed in Liège, the *Revue Blanche* was edited in Paris and in spirit remained essentially Parisian throughout the fifteen years of its existence. The review seems to have been conceived during the summer of 1889 by four young friends vacationing at the Belgian resort Spa: Auguste Jeunhomme, Joë Hogge and the two brothers Paul and Charles Leclercq.

Paul Leclercq became the review's editorial secretary and the first issue was edited in his Parisian apartment on the Champs-Élysées. Among the contributors to the first issue was Louis-Alfred Natanson, the youngest of three sons of a wealthy, Polish-born, Jewish banker. Alfred Natanson probably collaborated with his friend Joë Hogge in writing the introductory manifesto which made it clear that, while the new review intended to be open to all shades of opinion, its sympathies lay with the art and life of the present: "We love above all that literature, young and powerful, those pages that one feels palpitating with life, those authors whose faithful reproductions of reality mark what has come to be called 'the New School'."

In addition to his presumed collaboration on the introductory editorial, Alfred Natanson contributed to the first issue an article titled "Artistic and Literary News of Paris," and to subsequent issues literary and theatrical commentary as well as his own literary compositions. In the second issue Alfred Natanson was joined as a contributor by his older brother Thadée, whose prose-poem *Paraphrase* revealed the influence of his literary idol, Stéphane Mallarmé. From that point on the Natanson brothers played increasingly important roles in the life of the review. In October of 1891, at their urging, offices were established in Paris at 19 rue des Martyrs and on the fifteenth of the month the first issue of a "New Series" appeared in which Alfred and Thadée Natanson were identified as members of the editorial committee together with Paul and Charles Leclercq. Alexandre Natanson, the eldest of the three brothers, became director of the publication and handled its business affairs. Lucien Muhlfeld was appointed the paid editorial secretary. At this time printing of the review was moved from Liège to Paris. Direction of the *Revue Blanche* was essentially in the hands of the Natanson brothers and it was with the first issue of the "New Series" that the review began to establish itself as a major voice in the Parisian literary and artistic world. It had by this time grown to the respectable size of forty-eight pages and was scheduled to appear on the fifteenth of each month.

The Natansons' takeover of the *Revue Blanche* seems to have occurred naturally and without resistance or resentment on the part of the original founders. The new proprietors had the intelligence, energy and wealth necessary to ensure that the young journal survived and prospered. Of the three brothers it was Thadée who became most closely identified with the *Revue Blanche.* Frequently he is referred to in memoirs of the period as its editor, publisher or proprietor, although in title he remained only a member of the editorial committee. But as Paul Leclercq later remarked, "it was through the intuition and the influence of Thadée Natanson that *La Revue Blanche* became celebrated."[5]

Thadée Natanson and his brother Alfred both had attended the Lycée Condorcet, and many of the writers and artists who later formed the circle of the *Revue Blanche* first

2. **Pierre Bonnard (1867–1947)**
La Revue Blanche, 1894
gouache on paper
31¼ x 23½ in. (794 x 597mm)
New Orleans Museum of Art
New Orleans, La.
Gift of Mr. and Mrs. Frederick Stafford (76.421)

became acquainted while students at this remarkable institution.

> It was . . . that rarest of things, a school that people remembered with affection. It had a ferocious, unrelenting, all demanding attitude to knowledge, and it was able to claim for itself, in each generation, pupils who would arrive as clever and promising boys and leave as young men destined to make their mark in the world.[6]

Among the Lycée Condorcet pupils later to move in the circle of the *Revue Blanche* were Aurélien Lugné-Poë, future creator of the Théâtre de l'Oeuvre, Marcel Proust, Toulouse-Lautrec (who attended only until age twelve) and four of the future Nabis: Paul Sérusier, Maurice Denis, K. X. Roussel and Edouard Vuillard.

The symbolist poet Stéphane Mallarmé taught English for a number of years at the Lycée Condorcet and it was "traditional that very bright young men from the Lycée . . . should graduate, as it were, to regular attendance at Mallarmé's Tuesday evenings in the rue de Rome." Thadée Natanson was one of the bright young men who attended "Les Mardis," as was Paul Leclercq. So were Debussy and his friend the poet and critic Pierre Louÿs, both of whom also later wrote for the *Revue Blanche.* Vuillard introduced his Swiss friend Félix Vallotton to the group where they rubbed shoulders with older masters like Gauguin and Degas as well as such visiting foreign artists as the American expatriate Whistler and their contemporary the Norwegian painter Edvard Munch. Among the critics who attended the gatherings in the rue de Rome were Theodore Duret and Octave Mirbeau, both contributors to the *Revue Blanche,* as was, in fact, Mallarmé himself whose first contribution, *Chansons bas,* appeared in May of 1892. What exactly was discussed at these intellectual gatherings is not clear, but "most participants in their recollections agree that what counted was not an exchange of ideas but the 'enchanting monologue' of the master. It was this magic presence that converted the tiny and elegant drawing room into a radiating center of *l'art pour l'art.*"[7] If the Lycée Condorcet was the seedbed of *La Revue Blanche,* Mallarmé's Tuesday gatherings provided a hothouse atmosphere in which the ideas and attitudes that shaped the review could grow and flourish.

In April of 1893, twenty-five-year-old Thadée Natanson married Misia Godebski, talented and vivacious young daughter of the Polish sculptor Cyprien Godebski. An accomplished pianist who had studied with Gabriel Fauré, Misia was immediately at home among the artists and writers who had begun to gather around the *Revue Blanche.* During the first years of her marriage to Thadée Natanson, life was pleasant for this remarkable young woman "with her impulsive and spendthrift ways, her genuine gift for the piano, her starling chatter and her craving for the company of clever and distinguished men."

> [Misia] became the friend of Mallarmé, Verlaine, Paul Valéry, Bonnard, Jules Renard, Colette and Alfred Jarry. She was . . . present, when Debussy played *Pelléas et Mélisande,* on an upright piano, singing all the roles himself, to a small group of friends. She and her husband went to Oslo with Lugné-Poë to meet Ibsen."[8]

"She personifies *La Revue Blanche,* . . . this elegant, self-confident creature, daringly yet meticulously dressed," wrote Annette Vaillant, Misia's niece. "Gay and whimsical, with her winning ways and her bluntness and the swagger of a low-life princess, [she] was nonetheless everyone's muse."[9]

The Natansons' Paris apartment, like the offices of the *Revue* itself, became the gathering place for young artists, writers and intellectuals. In 1894, Misia and Thadée purchased *La Grangette,* a summer home in the village of Valvins near Fontainbleau. Nearby, on the bank of the Seine, was Mallarmé's summer cottage. Soon *La Grangette* also was filled with friends from the circle of the *Revue Blanche.*

"But by now," Misia wrote, "I had done some sorting out and invited, above all, those chosen by my heart. Vuillard and Bonnard installed themselves *chez moi* once and for all, and Toulouse-Lautrec came regularly from Saturday to Tuesday."[10] Mallarmé also was a frequent dinner guest, walking over from his nearby cottage.

Within a short time the number of the "chosen" had increased to such a degree that *La Grangette* was no longer adequate to house them all. In 1897 the Natansons purchased a larger summer home called *Le Relais* at Villeneuve-sur-Yonne where their entertaining continued unabated. Frequent visitors from the *Revue Blanche* circle, in addition to the three artists mentioned above, included Vallotton, Vuillard's brother-in-law the artist K. X. Roussel, Alfred Natanson and his wife the actress Marthe Mellot, and Lautrec's close friend the playwright and critic Romain Coolus, a regular contributor to the *Revue.*

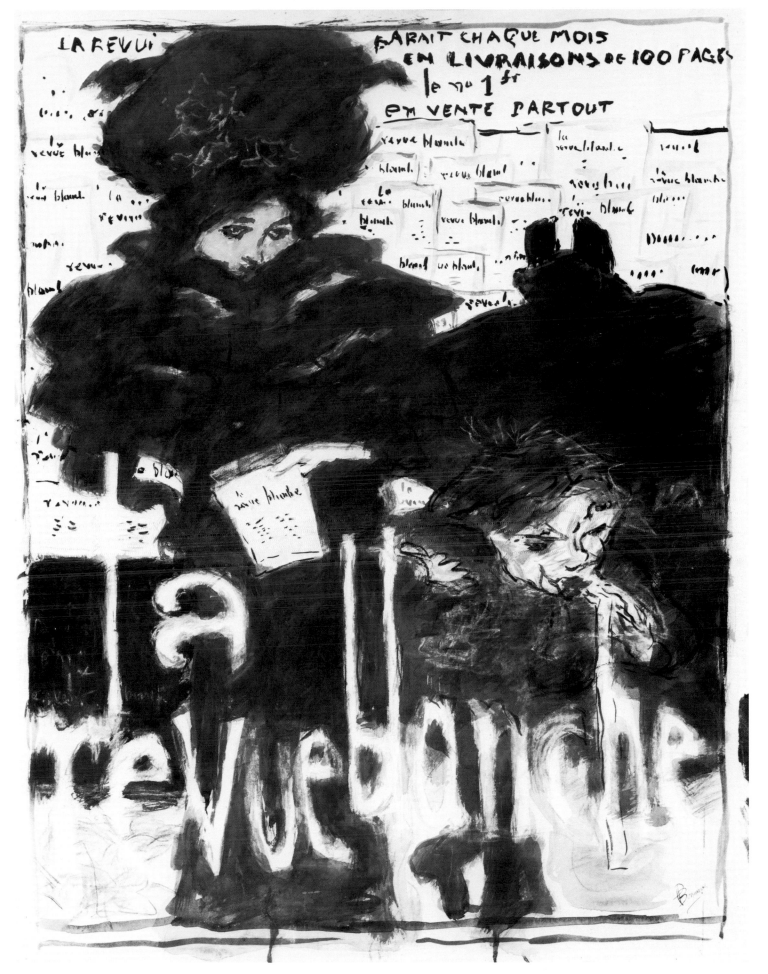

When Mallarmé died suddenly in September of 1898, the funeral near Valvins was attended by many of the *Revue Blanche* circle. Among the mourners who, after the burial, joined the Natansons at *Le Relais* were Renoir, Lautrec, Vuillard, Vallotton, Bonnard, Claude Terrasse, the art dealer Ambroise Vollard, Romain Coolus, the Belgian poet Maurice Maeterlinck and the writer Octave Mirbeau.

"The name that dominates the history of the *Revue Blanche* during the years 1891-1895," writes J. B. Jackson, "is that of Lucien Muhlfeld, its editorial secretary and recognized literary critic." Unlike the Natanson brothers and many of the review's other contributors, Muhlfeld had to work for a living. Perhaps partly for this reason he seems never to have been an intimate of the Natanson's circle. Serious, skeptical and sometimes dogmatic in his criticism Muhlfeld was, "in a milieu where others surrendered to generous but somewhat uncritical enthusiasms . . . a salutary influence."[11]

When Muhlfeld left the *Revue Blanche* at the end of 1895 to become drama critic for *l'Écho de Paris,* he was succeeded as literary critic at the review by Léon Blum who later in life as a leader of the Socialist Party served as Premier of France. Whereas his predecessor had been less than wholeheartedly enthusiastic about contemporary writing, Blum unhesitatingly announced, "I believe we must regard the present period as one of the richest . . . in our literature." Like Thadée Natanson he saw the critic more as an encourager of young writers than a judge. Blum was succeeded as literary critic early in 1900 by André Gide, who served in that capacity for little more than a year and seems never to have become an intimate of the Natanson's social circle.

The post of Editorial Secretary, vacated by Muhlfeld in 1895, was filled, after a brief interim appointment, by the enigmatic Félix Fénéon, who guided the review for the remainder of its existence. Although an anarchist in his political views, Fénéon proved to be an efficient and conscientious editor. Thadée Natanson described him as "the most effective and delightful editorial secretary [the Review] ever had."[12] Fénéon shared Natanson's enthusiasm for art and artists. He actively promoted the work of Georges Seurat, and arranged for a posthumous one-man exhibition of his paintings in the offices of the *Revue Blanche* in 1900. Described as resembling a "Yankee" with the "goatee of a Mormon chief,"[13]

Fénéon was frequently depicted by his artist friends including Vallotton, Lautrec (cat. no. 32), Vuillard (cat. no. 81), Seurat and Paul Signac. When asked by the latter to pose for a portrait Fénéon accepted with delight, remarking, "I very much like the idea that if my performance is satisfactory it will be eternalized on the walls of future picture galleries whose catalogues will say: '*Paul Signac (1863-1903): Portrait of an Unknown Young Man.*'"[14]

During Fénéon's time as Editorial Secretary the Dreyfus Affair became a *cause célèbre,* dividing the nation into hostile camps of pro and anti Dreyfusards, and revealing a deep and ugly vein of anti-Semitism in the body politic. Captain Dreyfus, a Jewish officer in the French army, was wrongfully convicted of treason and imprisoned in 1894. The controversy, after smouldering quietly for four years, burst into flame in 1898, fanned by Émile Zola's open letter "*J'accuse.*"

The extent to which the nation was preoccupied by the *Affaire Dreyfus* is indicated by Marcel Proust's account in *Remembrance of Things Past* of a conversation with a hotel clerk who "could not go away without telling me that Dreyfus was guilty a thousand times over."[15]

Thadée Natanson describes Vuillard's reaction to a discussion of Dreyfus' plight: "His eyes brimmed fuller of tears than those of any of his companions, who were about to join him in commiseration for the condemned man. They heard an unrecognizable voice declare: 'I don't give a damn about Dreyfus. It's my country I weep for.'"[16]

The *Revue Blanche* was strongly pro-Dreyfus, and as the controversy dragged on, political concerns came increasingly to the fore in its editorial policy. J. B. Jackson suggests that this preoccupation with politics caused the review to lose the balance it had so adroitly maintained, the openness to all schools of literature and art and all shades of opinion that had characterized its early years, and that the Dreyfus affair thus contributed to the ultimate dissolution of the *Revue Blanche* in 1903.

There were other factors as well. The review never had been able to show a profit or even to pay its own way, and the Natanson brothers' financial situation was less solid at the end of the century than it had been a decade earlier. Thadée's unfortunate business ventures, including investments in tramways and hydroelectric plants, did not improve the situation.

Mallarmé had died in 1898. Lautrec was confined for alcoholism the following year, his health broken. He died in September of 1901. Thadée and Misia Natanson were divorced in 1904. The principals of the *Revue Blanche* had been in their twenties when the publication was launched. By the end of the century all had passed the age of thirty and the courses of their lives had begun to diverge.

Finally, by 1900, the ideas and aesthetic attitudes that characterized the *Revue Blanche* had begun to seem slightly old fashioned to the rising generation; "it began to 'date' terribly."

> The *Revue Blanche,* which had succeeded in attracting the general public, had lost the battle for the young. It is a fatal blow for a review of the avant garde.[17]

Alfred Jarry, in an essay called "Questions of the Theatre" published in the *Revue Blanche* in 1897[18], had written prophetically:

> We too shall become solemn, fat and Ubu-like and shall publish extremely classical books which will probably lead to our becoming mayors of small towns where, when we become academicians, the firemen will present us with Sèvres vases, while they present their moustaches on velvet cushions to our children. And another lot of young people will appear, and consider us completely out of date, and they will write ballads to express their loathing of us, and there is no reason why this should ever end.

La Revue Blanche ceased publication abruptly with the issue of April 15, 1903.

Bret Waller

FOOTNOTES: *La Revue Blanche*

1. J. B. Jackson, *La Revue Blanche (1899-1903): Origine, influence, bibliographie* (Paris: Lettres Modernes, 1960) p. 15.
2. Lucien Muhlfeld, *Revue Blanche* (Dec. 1893), p. 353, quoted in Jackson, *Revue Blanche,* p. 11.
3. John Russell, *Edouard Vuillard 1868-1940* (Toronto: Art Gallery of Ontario, 1971) p. 53.
4. Stéphane Mallarmé, *Divagations* (Bibliothèque de la Pléiade) p. 1576, quoted in Jackson, *Revue Blanche,* p. 26.
5. Paul Leclercq, letter published in *Arts* (April 16, 1948) p. 2, quoted in Jackson, *Revue Blanche,* p. 30.
6. Russell, *Vuillard,* p. 12.
7. Klaus Berger, "Mallarmé and the Visual Arts," *Les Mardis: Mallarmé and the Artists of his Circle* (Lawrence, Kansas: The University of Kansas Museum of Art, [1965]) p. 51.
8. Russell, *Vuillard,* p. 55.
9. Annette Vaillant, "Les amités de la *Revue Blanche,*" *Derrière le miroir* (Paris) no. 158-159 (April-May 1966), pp. 1-15.
10. Arthur Gold and Robert Fizdale, *Misia: The Life of Misia Sert* (New York: Morrow Quill Paperbacks, 1981) p. 56.
11. Jackson, *Revue Blanche,* p. 43.
12. Thadée Natanson, *Mercure de France* (June 1, 1949) p. 376, quoted in Jackson, *Revue Blanche,* p. 98.
13. Fernand Gregh, *L'Age d'Or* (Paris: B. Grasset, 1947) p. 192.
14. Francis Jourdain and Jean Adhémar, *T-Lautrec* (n.p.: Éditions Pierre Tisné, 1952) "*Répertoire notices et tables*" (Appendix) p. 93.
15. Marcel Proust, *Remembrance of Things Past,* 3 vols., trans. C. K. Scott Moncrieff and Terence Kilmartin (New York: Vintage Books, 1982) 1:864.
16. Thadée Natanson, *Peints à leur tour,* quoted in Russell, *Vuillard,* p. 105.
17. Jackson, *Revue Blanche,* p. 145.
18. Alfred Jarry, "Questions de Théâtre," *Revue Blanche,* n.s. 12 (1897): 16.

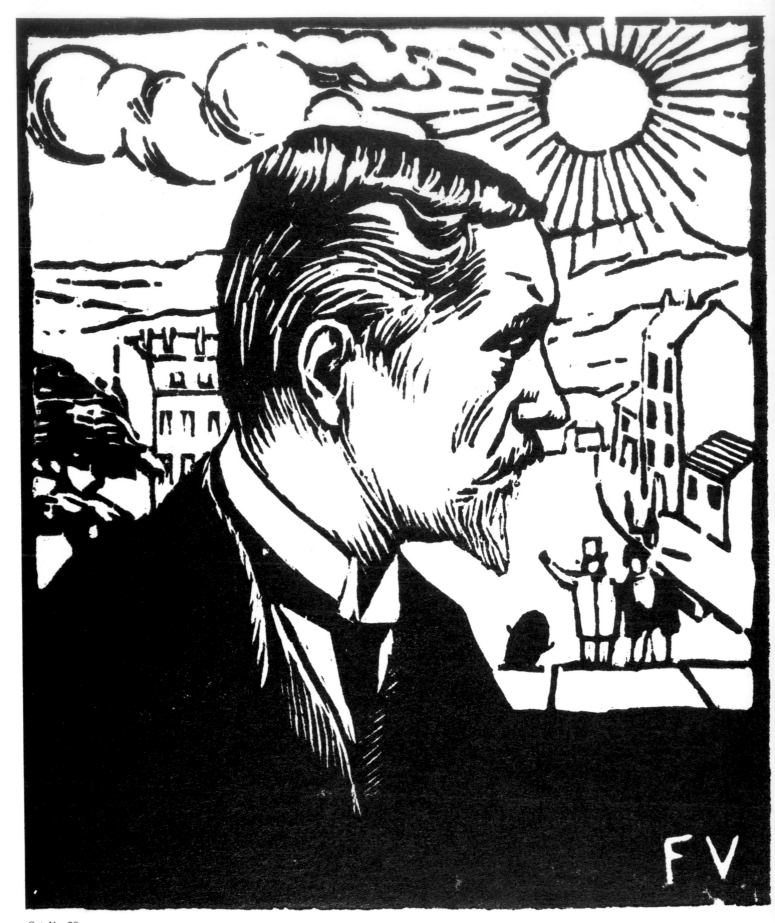

Cat. No. 53

ARTISTS AND THE *REVUE BLANCHE*

Although the first issue of the *Revue Blanche,* printed in Liège in 1889, carried an article by Alfred Natanson called "Art and Literary News of Paris," serious art criticism became a regular feature of the review only in 1893, when Thadée Natanson began a series of exhibition reviews and articles on art and artists that continued almost until publication ceased in 1903. In addition to essays on such general topics as "Art Nouveau," "Women Painters and Sculptors" and "Painters of Christiania," Thadée Natanson contributed reviews of the official salons and such anti-establishment exhibitions as the Rose-Croix Salon of 1895 and the *Salon des Indépendants.* He also wrote appreciative articles on individual artists: Monet, Van Gogh, Cézanne, Berthe Morisot, Renoir, Manet, and Georges Seurat. Clearly Thadée Natanson was blessed with a "good eye." The artists singled out for attention in his columns, for the most part, are now counted among the early masters of modern art. But Natanson's tastes, as evidenced by his personal collection (sold at auction in 1908), and his friendships—as well as his writing—ran toward the art of the group of young painters called "Les Nabis."

Nabi is the Hebrew word for "prophet," and the young men who, around 1889, formed the semi-secret, semi-serious brotherhood called "Les Nabis," did, indeed, regard themselves in some sense as prophets of a new artistic order. Inspired by the ideas of Paul Gauguin as transmitted through Paul Sérusier (one of their number who had actually met and worked with the great man in Brittany), the Nabis dreamed of an art in which the subject represented was no more important than the means by which it was depicted. "Remember," wrote Maurice Denis in the Nabi manifesto of 1890, "that a picture—before being a war-horse, a nude, or some sort of anecdote—is essentially a flat surface covered with colors arranged in a certain order."[1]

Founding members of the Nabis were Pierre Bonnard, Maurice Denis, H.-G. Ibels, René Piot, Paul Ranson, Ker-Xavier Roussel, Paul Sérusier and Edouard Vuillard. Among the later adherents were Aristide Maillol and Félix Vallotton. Although students at the Académie Julian at the time of the group's formation, several of the original Nabis had previously attended the Lycée Condorcet where they may have come into contact with Thadée and Alfred Natanson.[2]

When the *Revue Blanche* began, in 1893, to include an original print as the frontispiece in each issue, most of the commissioned artists were Nabis. Issued again in 1895 in portfolio form as *Album de la Revue Blanche* with a cover by Bonnard, the twelve prints were by Bonnard, Charles Cottet, Denis, Ibels, Ranson, Odilon Redon, Joseph Rippl-Ronaï, Roussel, Sérusier, Henri de Toulouse-Lautrec, Félix Vallotton and Edouard Vuillard.

Both Bonnard and Lautrec created lithographic posters for the *Revue Blanche* that must be counted among the masterpieces of their kind (cat. nos. 10 and 40), and the same two artists also collaborated in the production of illustrated humorous supplements to the review, *NIB* (cat. no. 38) and *Le Chasseur de Chevelures* (*The Scalp Hunter*) (cat. no. 30). To the latter Félix Vallotton contributed a series of woodcut portraits illustrating Romain Coolus' satirical verses given the collective title *Petit Tussaud du Rondel* ("Little Wax Museum of the Rondel"). Edouard Vuillard's lithograph was the first to appear as a frontispiece in the *Revue Blanche* series and his was the inaugural one-man exhibition in the suite of offices on the rue des Martyrs into which the *Revue Blanche* moved in 1891.[3] Some forty artists had works published or reproduced in the *Revue Blanche* during its fifteen-year existence, but these four—Bonnard, Lautrec, Vallotton and Vuillard—were closest to the center of the circle of young poets, playwrights, musicians and intellectuals that formed around the *Revue Blanche* in the last decade of the century.

Edouard Vuillard (1868–1940)

In all probability Edouard Vuillard was the first of the four artists under consideration here to meet the Natanson brothers and through them to be introduced to the circle of the *Revue Blanche.* According to John Russell, "It was through Pierre Véber [future drama critic for the *Revue Blanche*] that Vuillard first met the Natansons as a schoolboy."[4] Véber, Vuillard and the Natanson brothers all attended the Lycée Condorcet, "the only *lycée* in Paris attended by day pupils, who enjoyed freedom of movement outside school hours, who were drawn for the most part from families very much in the swim of Parisian life, and who were in the habit of supplementing their classical education with visits to theatres and art galleries."[5]

85. Edouard Vuillard (1868–1940)
Self-Portrait, 1889
charcoal
8 x 6¾ in. (203 x 172mm)
Lent by Mr. Alfred Ayrton

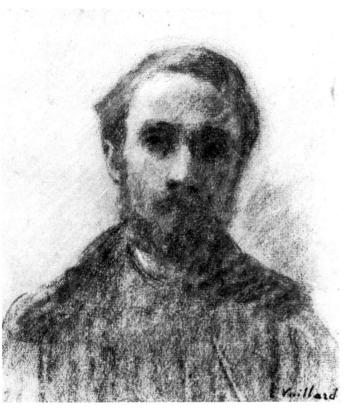

Cat. No. 85

Vuillard was born November 11, 1868, at Cuiseaux, Saône-et-Loire. He entered the Lycée Condorcet as a scholarship student in 1879, two years after his family moved to Paris and four years before the death of his father, a retired colonial army officer.[6] Following his father's death Vuillard's mother supported the family by setting up in business as a dressmaker, working from her apartment. Vuillard remained close to his mother throughout her long life (she died in 1928) and many of his paintings from the *Revue Blanche* period depict his mother and sister in the intimacy of their small apartment, sewing, dining or quietly conversing.

After completing his studies at the Lycée Condorcet, Vuillard, together with his close friend and future brother-in-law K.-X. Roussel, undertook the study of art, beginning with the academic painter Diogène Maillart and moving in 1888 to the Académie Julian where they met the future Nabis.

By 1890 Vuillard was sharing a small studio at 28 rue Pigalle with Bonnard, Maurice Denis and Aurélien Lugné-Poë, actor and future founder of the Théâtre de l'Oeuvre, who later wrote:

> The little studio . . . was rented in the first place by Pierre Bonnard. We pooled our resources to keep it. I was one of the first to be in default with my share of the expenses, but we stayed together as a band of brothers for the next fifteen years.[7]

Vuillard's portrait of Lugné-Poë (cat. no. 74), now in the collection of the Memorial Art Gallery, dates from this period.

In 1891 Vuillard was given a one-man exhibition—his first—in the new offices of the *Revue Blanche* in the rue des Martyrs. Vuillard and his friend Bonnard began exhibiting (with other kindred spirits) at the gallery of Le Barc de Boutteville in that same year, and were "discovered" there by the critics. "They have the gift of nuance," wrote Gustave Geffroy. "They can manipulate every possible complication of line—symmetrical, asymmetrical, knotted and unknotted—in a delightfully convoluted and decorative way."[8] Vuillard was described by Geffroy as "an intimist with a delightful sense of humor."

> He knows how to be funny and sad, all at once, with a hand that is as sure as it is light. Much in these interiors is left in heavy shadow, but M. Vuillard knows how to contrast this with a patch of sparkling colour or a magical outburst of light.

Only a few years out of art school Bonnard and Vuillard had "arrived." "Both painters, like Lautrec again, are striking examples of the precociousness that was a characteristic of the *fin-de-siécle* period."[9]

By 1891 Vuillard was one of the artists, writers and intellectuals attending "*les Mardis,*" the Tuesday evening gatherings held in the home of the Symbolist poet Stéphane Mallarmé. Much has been made of the parallels between Vuillard's painting of this period and Mallarmé's poetry. "To *name* a thing," wrote Mallarmé, "is to suppress three-quarters of the pleasure in the poem which stems from the joy of divining little by little; *to suggest,* there is the dream."[10] Vuillard's painting of this period certainly is more suggestive than descriptive, and the quiet intimacy of his domestic interiors accords well with the spirit of Mallarmé's verse in which "emotions and ideas are purposely muted."[11] Albert Aurier, reviewing the 1892 Nabi exhibition at Le Barc de Boutteville's, described Vuillard as "*intimiste Verlainien.*"[12]

John Russell suggests that the ideas of the Belgian dramatist Maurice Maeterlinck as transmitted through the Théâtre de l'Oeuvre also may have influenced Vuillard who regularly designed sets and programs for his friend Lugné-Poë's theatrical productions.

> Maeterlinck wanted to do away with the idea of the theatre as a place where things happened in an obviously 'dramatic' way. '*The Master Builder,*' he wrote in April, 1894, 'is one of the first of those modern plays which take ordinary motionless life for their subject and reveal it to us in all its gravity, all its clandestine poignancy.'[13]

After 1900 Vuillard's style gradually changed. His palette became lighter and daylight flooded into his previously darkened interiors. But during the *Revue Blanche* period, as André Chastel observes, "It is undeniable that, through his muted tones, the density of his color, his difficult and solid compositions, by means of effects that one perceives slowly like a perfume which evaporates, he transposed into his art the methods of symbolist poetry."[14]

Vuillard was, in Misia Natanson's words, one of those "chosen by my heart" to summer at *La Grangette* and later at *Le Relais* with her and her husband Thadée. According to Misia, Vuillard was in love with her and revealed his feeling on an evening walk in the summer of 1897.

> Suddenly our eyes met. In the growing darkness I could see only the gleam of his sad eyes. He burst into sobs. It was the most beautiful declaration of love any man ever made to me.[15]

Despite its breathless tone there may be some truth in Misia's account. In a letter that summer to his friend Vallotton, Vuillard wrote from *Le Relais,* "I am torn by confusing vexations,"[16] and Thadée Natanson recalled many years later, "As for his friendships with women, they only added to his perturbation of spirit."[17] Vuillard's beautiful portrait of Misia with Thadée hovering obscurely in the background (cat. no. 78) dates from the year of the artist's supposed profession of love for his friend's wife.

In 1900 Vuillard spent the summer with Félix Vallotton at Romanel near Lausanne, Switzerland. The previous year Vallotton had married the daughter of art dealer Bernheim-Jeune and it was through this connection that Vuillard met Lucie Hessel, wife of Jos Hessel, a young member of the Bernheim-Jeune staff. Madame Hessel was to become Vuillard's patroness, inspiration and intimate friend, influencing the direction of his life for the next forty years.

"There is an evident contrast," observes John Russell, "between Misia Natanson, with her improvident ways, her unfeigned love of music and poetry, her sexy little muzzle and her kaleidoscopic private life, and the majestic figure of Madame Hessel."

> The Hessel milieu was one in which painters and writers and actors and actresses were welcome, but it was not a milieu to which they were indispensable; nor was it a milieu in which the ideas most naturally in favor were those of the avant-garde."[18]

A chapter in Vuillard's life ended with the closing of the *Revue Blanche,* but he, like so many of the others who participated in the life of that journal, remembered it later with affection. "The *Revue Blanche,*" he recalled, "brought us all together—painters, critics, singers, writers—the whole Montmartre group."[19]

Pierre Bonnard (1867–1947)

Pierre Bonnard was intended by his parents for a legal career. Born near Paris at Fontenaye-aux-Roses into an upper middle class family (his father headed an office in the Ministry of War), Bonnard received a sound, traditional education and, around 1885, entered law school in Paris. After a short time, however, he curtailed his legal studies in order to enter the École des Beaux-Arts and during the same period began to work at the Académie Julian. He met there, in 1888, the other young artists who were to form the nucleus of the Nabis.

According to one account it was Maurice Denis who introduced Bonnard to Vuillard and K.-X. Roussel, and Bonnard who "took them along to the Académie Julian." Lugné-Poë, future director of the Théâtre de l'Oeuvre, is supposed to have introduced Vuillard to Denis.[20] However this may be, it is certain that by 1890, Bonnard, Vuillard, Denis and Lugné-Poë were sharing a small studio at 28 rue Pigale. As Lugné-Poë later recalled,

> It was in that little studio, at the very top of a house . . . that the Neo-Traditionalists[21] came into being . . . and it was there that the critic Gustave Geffroy came to see us. I had known him since my childhood . . . It was also from number 28 that I bore off to *Art et critique* Maurice Denis's manifesto, which can fairly be called historic, on behalf of the Neo-Traditionalists.[22]

Bonnard, like the other Nabis, had a secret nickname. He was called "*Le Nabi trés japonard*" ("The Ultra-Japanese Nabi") because of his love of Japanese prints. This admiration for Japanese design is evident in Bonnard's first lithographic poster advertising France-Champagne, which appeared on the walls of Paris early in 1891. He had sold the design for 100 francs—his first commercial success as an artist. The poster evidently was seen and admired by Toulouse-Lautrec. As a result Bonnard reportedly met Lautrec and introduced him to the lithographic printing establishment of Edward Ancourt where the France-Champagne poster had been printed and where the first of Lautrec's great posters was produced.[23]

Bonnard, Vuillard and other Nabis together with Lautrec and some of Gauguin's followers began in 1891 to exhibit at Le Barc de Boutteville's new gallery. In the same year Vuillard had his first one-man show in the newly established offices of the *Revue Blanche* in the rue des Martyrs. If Bonnard had not previously met Thadée Natanson he must have done so at this time.

Natanson later described the Bonnard of those early days: "This slim, active man seems tall, although he stoops a little and folds up on himself . . . He strokes his short beard which curls loosely on his obstinate chin . . . His nearsightedness is that of an observer, but it eliminates useless details. Behind his spectacles, unusually lively pupils glance at or fix upon successive objects, to make them his own."[24]

By 1894 Natanson had begun to purchase Bonnard's paintings and in that year Bonnard contributed a lithographic frontispiece to the *Revue Blanche* and also created his great poster advertising the magazine (cat. nos. 2 and 10). The model for the enigmatic female depicted in the poster is believed to have been Maria Boursin who called herself Marthe de Méligny and with whom Bonnard had become intimate around that time. Their companionship, regularized by marriage only in 1925, continued until her death in 1942.

Thadée Natanson lent several paintings to Bonnard's first one-man exhibition held in 1896 at the gallery of Durand-Ruel. Critic Gustave Geffroy, in his review of the exhibition, compared Bonnard's work with Vuillard's:

> Vuillard is a clearer and more vivid colorist, more boldly bursting forth into rich patterns of blue, red, golden yellow; and at the same time one feels that his spirit is melancholy, his thoughts are grave. Bonnard, on the other hand, is a gray painter, fond of purplish, russet, somber tones; and yet in every stroke his shrewd observation, his impish gaity are revealed with charming distinction . . . A curious line in movement, of a monkeylike suppleness, captures these casual gestures of the streets, these fleeting expressions born and vanished in an instant. It is the poetry of a life that is past, the remembrance of things, of animals, of human beings. The amused regard of the artist shifts from city to country, and thus is created, delicately, unerringly, a work full of promise, ingenious and thoughtful, in touch with real life.[25]

In 1897 Bonnard executed illustrations for the *Revue Blanche* edition of Peter Nanson's novel *Marie.* He also did lithographic covers for six songs (cat. no. 12) with music by his brother-in-law Claude Terrasse and lyrics by the poet Franc-Nohain for the Théâtre des Pantins, a puppet theatre created by Terrasse, Franc-Nohain and Alfred Jarry whose scatological drama *Ubu-Roi* had scandalized the audience at

7. Pierre Bonnard (1867–1947)
Design for Théâtre Libre Program, c. 1891
watercolor and ink
12⅜ x 7⅞ in. (317 x 202mm)
The Atlas Foundation

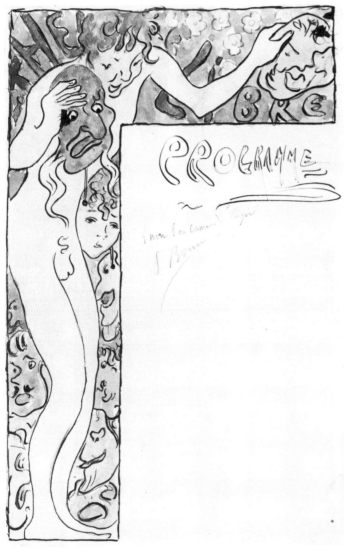

Cat. No. 7

the Théâtre de l'Oeuvre the year before (cat. nos. 110 and 111). Jarry wrote regularly for the *Revue Blanche* between 1896 and 1903, and both Terrasse and Franc-Nohain also contributed occasional essays. Bonnard, Vuillard, Vallotton and others created sets and decorations for the Théâtre des Pantins which existed for only a few years.

The Nabis exhibited together for the last time in 1899 and by the time the *Revue Blanche* closed in 1903, Bonnard, like Vuillard, had begun to move in different social circles. Bonnard and his companion Marthe de Méligny spent their summers outside Paris in one or another of the little villages along the Seine between Paris and Rouen. Bonnard had begun to receive portrait commissions and in a humorous visual autobiography executed around 1910, Bonnard depicted himself at this period as a *"grand peintre mondain"* at his easel painting a socialite who reclines on a chaise lounge in the background.

Another drawing in Bonnard's visual autobiography shows the bustling offices of the *Revue Blanche* as the artist remembered them from the 1890's. In the foreground authors Octave Mirbeau and Henri de Régnier converse; behind them are Alexandre and Thadée Natanson and farther back still are three other figures, one unidentified, one Jules Renard, the writer, and the third the artist himself in profile; across the room Editorial Secretary Félix Fénéon bends over his desk; behind him on the wall is Bonnard's *Revue Blanche* poster and at the far left Misia Natanson is seen framed in the open doorway trailed by an unidentified top-hatted gentleman.

Félix Vallotton (1865–1925)
Although Swiss-born Félix Vallotton began his studies at the Académie Julian five or six years before any of the young men who formed the Nabi brotherhood in 1889, he was not one of the original members of that fraternity, exhibiting with them at Le Barc de Boutteville's for the first time only in 1892. Even his secret nickname, *le Nabi étranger*—"The Foreign Nabi," suggests that he was never an intimate member of the group. Like Bonnard and Vuillard he was more interested in depicting the daily life of Paris than in the vague and mysterious religious symbolism of the other Nabis. But unlike the first two, who depicted quiet interiors

19

68. **Félix Vallotton (1865–1925)**
Les Rassemblements, 1896
book cover
From the collection of Mr. and Mrs. Herbert D. Schimmel

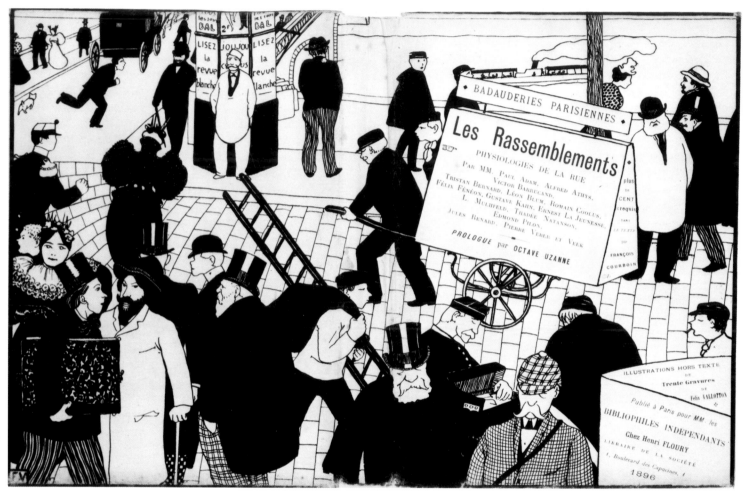

Cat. No. 68

steeped in poetic penumbra, Vallotton often focused on the rude, vigorous, sometimes violent life of the streets. In woodcuts like *l'Étranger* (cat. no. 63) depicting ladies of the evening accosting tophatted gentlemen, Vallotton is closer to his friend Lautrec than to the Nabi sensibility. And in topical prints like *La Charge* (cat. no. 60) depicting police brutally attacking an anarchist demonstration Vallotton approaches the concerns of contemporary journalism more nearly than do any of his friends. Even Vallotton's chosen graphic medium, the woodcut, was rarely used by the other Nabis who preferred the subtler effects of lithography. On the other hand, his famous woodcut series *Intimités* (cat. nos. 69–72) treating various aspects of the emotional relationships between men and women, is permeated by the psychological tension one often senses in Vuillard's work and finds much more explicitly in the work of the Norwegian painter Edvard Munch, whose own prints may have been influenced by Vallotton's example (cat. no. 42a).

Born of conservative Protestant parents in Lausanne, Switzerland, in 1865, Vallotton came to Paris to study art when only seventeen and in 1882 enrolled at the Académie Julian. He exhibited a portrait three years later in the *Salon des Artistes Français* attracting the attention of critic Paul Boucher who pronounced it "meticulous and dry" adding, "a little less dryness in the accessories would perfect the work."[26] Undaunted, Vallotton continued to show at the annual Salons as well as in various exhibitions in his native Switzerland. Like Lautrec and Bonnard he participated in the first *Salon des Indépendants* in 1891 where the critic Roger-Marx commented favorably on his work.

According to Charles Chassé, by 1887 "Vallotton associated in Paris with Toulouse-Lautrec and Charles Cottet. It was the latter who introduced him to the Nabis . . ."[27] Ashley St. James writes that by 1892 Vallotton was "very close to Toulouse-Lautrec"[28] and Adhémar suggests that Vallotton's woodcuts may have had an influence on Lautrec's "black" lithos of 1893, like *Mme. Abdala* (cat. no. 29).[29]

However it was that they became acquainted, it is clear that by 1893 Vallotton was in contact with the Nabis, for in that year he participated for the first time in their exhibitions at le Barc de Boutteville's along with Lautrec (who never actually was a member of the Nabi brotherhood).

It was around 1893 also that Vuillard undertook to make Vallotton's woodcuts more widely known, obtaining for him the commission of a woodcut portrait of the writer Romain Coolus and attempting to sell some of his blocks to Thadée Natanson for the *Revue Blanche*.[30] In a review of the Salon des Indépendants in April, Natanson had praised Vallotton's woodcuts, as had also the critic Roger-Marx. "The paintings of M. Vallotton," Natanson wrote, "and especially his beautiful woodcuts . . . might suggest reflections on the value of what one could call *the material quality* of a work of art and on that which one is tempted to call *plastic irony.*"[31]

Vallotton had begun his printmaking career in 1881 as an etcher and had taken up the woodcut medium a decade later, inspired by the experiments of Gauguin and Emile Bernard.[32] Unlike the commercial wood engravers who worked with fine-pointed engraving tools on the end grain of their blocks building up carefully modeled images from delicate white lines, Vallotton attacked the broad side of the wooden plank with knives and gouges creating bold black and white images that recalled the works of early European masters like Dürer as well as the popular woodcuts of Japanese artists like Hokusai and Hiroshige. Octave Uzanne wrote in 1892,[33] "He has cut on blocks of soft pearwood diverse scenes of contemporary life with the candor of a xylographer of the sixteenth century."

In February, 1894, Vallotton's *Three Bathers* (cat. no. 62) appeared as the *Revue Blanche* frontispiece—the first of many commissions executed by the artist for the review. Over the next six years he would contribute more than seventy illustrations—mostly portraits. In 1896 Vallotton created a woodcut cover and other illustrations for *Les Rassemblements: Physiologies de la Rue,* a collection of essays with a prologue by Uzanne and contributions by Thadée Natanson and a number of other *Revue Blanche* regulars (cat. no. 68).

Late in 1898 Vallotton's woodcut series *Intimités* (cat. nos. 69-72) was published by the *Revue Blanche* and exhibited in the editorial offices. In the January, 1899, issue Thadée Natanson wrote, "One can cherish them for a thousand reasons or for only one, but it is perhaps in the alliance of the two most fundamental aspects of these prints—power of expression or pictorial value, prolongation of meaning or moral significance—that it is necessary to seek their unforgettable savour."[34] Also in 1898 a monograph on Vallotton's graphic works by Julius Meier-Graefe was published in Paris and Berlin.

By 1893 Vuillard and Vallotton had become close friends. Vallotton accompanied his comrade to Mallarmé's *Mardis,* and both artists were regular visitors at the Natansons' summer homes.

"My dear friend," wrote Vuillard from *Le Relais* in the summer of 1897, "Yesterday at table Thadée read us your letter, which cheered us all up. Everyone here loves you."[35] And in a letter written jointly by Vuillard and Misia later that year the latter, after remarking, "Vuillard is acting as my husband, as you can see, my dear Vallo, but naturally he is not behaving well," extends an invitation that has almost the sound of a summons:

> You know we are not leaving here for at least a week. Come quickly and spend a few days. The weather is marvelous and you will find the intimacy you were crying for this summer.[36]

The peremptory tone of this "invitation" hints at the possessiveness of Proust's Madame Verdurin, an unpleasant arriviste supposedly modeled in part on Misia Natanson: "Each 'new recruit' whom the Verdurins failed to persuade that the evenings spent by other people, in houses other than theirs, were as dull as ditch-water, saw himself banished forthwith."[37]

The bonds that held the little group together, though still intact, had begun to weaken by 1899 as is suggested by a letter on *Revue Blanche* stationery from Vallotton to Alfred Natanson:

> It is from your place with Fénéon's pen that I write you; . . . I go regularly to the *Revue,* almost every afternoon, to look around the office, I have only regret for not having seen you [there.] Thadée is invisible also.[38]

Earlier that year Vallotton had married the daughter of the art dealer Bernheim-Jeune, and in the following months his interests turned increasingly to painting. Together with Bonnard and Vuillard, Vallotton participated in the last Nabi exhibition at Durand-Ruel's. After the turn of the century and the collapse of the *Revue Blanche,* Vallotton abandoned the woodcut medium almost entirely and his painting style also changed, moving away from the subtlety and suggestiveness of Bonnard and Vuillard toward a cool, precise realism.

Henri de Toulouse-Lautrec (1864–1901)

Exactly how and when Lautrec joined the circle of the *Revue Blanche* is difficult to ascertain. Although never one of the Nabis, he exhibited with them at the Gallery of le Barc de Boutteville from 1891 onward. Reportedly Lautrec was so impressed by Bonnard's 1891 France-Champagne poster that he "searched out its creator and, enchanted by his and Vuillard's small paintings, tried to find purchasers for them,"[39] but many years later Vuillard told Germain Bazin that he had met Lautrec in 1892 or 1893.[40] In March of 1894 Lautrec's lithograph "Carnival" appeared as the frontispiece for the *Revue Blanche* and in June, Lautrec illustrated an issue of *Le Chasseur de Chevelures* (cat. no. 30), the review's humorous supplement with text by Tristan Bernard. Clearly by this time he had become a member of the inner circle.

Descendant of an ancient, noble family, Lautrec was deformed as the result of two childhood accidents that left both his legs disproportionately short in relation to his fully developed upper body. Despite his diminutive stature he was a commanding personality. In 1895 *Revue Blanche* contributor Jules Renard noted in his diary, "Toulouse-Lautrec. The oftener you see him the taller he grows. He ends up by being taller than average."[41]

Having come to Paris in 1882, at age eighteen, to study art, Lautrec entered the atelier of Léon Bonnat and, when that closed shortly after his arrival, moved to the studio of the academic painter Fernand Cormon. Among his classmates there were Vincent van Gogh and Emile Bernard, but unlike the latter who espoused Gauguin's gospel of primitivism, Lautrec admired above all the refined draughtsmanship of Degas. He also shared Degas' interest in the drama of modern urban life.[42]

In 1886 Lautrec left Cormon's atelier and established his own studio. He had already begun to frequent the night spots of Montmartre in search of subject matter and some of his work was on permanent display at *Le Mirliton,* the cabaret whose proprietor Aristide Bruant "served as rudest of hosts and perambulating singer, probably the best of the era."[43] Lautrec later depicted Bruant several times in his habitual costume of long black cloak, boots and broad-brimmed hat, enlivened by a bright red scarf (cat. nos. 21 and 27).

In 1891, the year in which the *Revue Blanche* centralized its operations in Paris, Lautrec produced the first

30. Henri de Toulouse-Lautrec (1864–1901)
Le Salon du Chasseur de Chevelures, 1894
From the collection of Mr. and Mrs. Herbert D. Schimmel

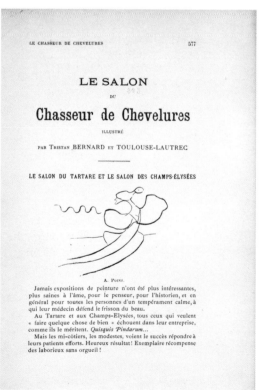

Cat. No. 30

of his great color lithographic posters, *Le Moulin Rouge, La Goulue,* apparently inspired by Bonnard's Champagne-France poster that had appeared a few months earlier.[44] Although Bonnard created only one other poster, Lautrec's first masterpiece of the genre was followed by dozens more including, in 1895, one for *La Revue Blanche* depicting Misia Natanson as an ice skater in plumed hat, fur cape and muff (cat. no. 40).

This was one of the first of Lautrec's numerous depictions of Misia. By then a frequent visitor to the Natanson's summer place ("Toulouse-Lautrec came regularly from Saturday to Tuesday," Misia wrote), Lautrec painted Mme. Natanson at the piano, in the garden reading and at the theatre. Once in a malicious moment he even depicted her as the jowly proprietress of a bordello presiding imperiously over the dinner table meekly flanked by Vuillard and Vallotton with husband Thadée, his back to the viewer, lightly sketched in the foreground. One portrait of Misia served as the model for the lithographic cover for the last portfolio of *L'Estampe Originale* published in 1895. Misia is seen from the back seated in a theatre loge as the curtain rises, recalling Lugné-Poë's remark that "no dress rehearsal could properly raise its curtain" if the Natansons were not in their box with "the radiant and sibyllene Misia" seated in the first row.

That Lautrec by 1894 had become a regular visitor to the *Revue Blanche* offices is attested by a number of his sketches on *Revue Blanche* stationery dating from that and subsequent years.[45] Thadée Natanson has left a vivid description of Lautrec's performances at the offices on the rue Laffitte where, perched on a green leather sofa, his short legs dangling, he held court, astonishing unwary visitors as much by his vivid monologue as by his bizarre appearance. Despite Lautrec's antics, Natanson remarks, nothing escaped the sight or hearing of the sensitive observer hiding behind the buffoon's mask.[46]

In the winter of 1895 Lautrec staged a remarkable party for Alexandre, eldest of the Natanson brothers, whose new home featured mural decorations by Vuillard. Not only did Lautrec design invitations for the fête, but with his friend the painter Maxime Dethomas, he served as bartender, creating "American and other drinks" in previously undreamt of combinations.[47]

23

On another occasion Lautrec, the writer Romain Coolus and Misia Natanson spent nearly a week traveling from Paris to the Natansons' nearby summer place, stopping in every inn and tavern along the way.[48]

Lautrec's drinking became an increasing problem as the decade progressed. "Lautrec is here," wrote Vuillard to Vallotton from *Le Relais* in the summer of 1897, "and begins to be calmer, it does not go without hitches; but we must not despair, he has good moments and is truly very attached to Thadée and his wife."[49]

A series of letters written early in 1895 by Berthe Sarrazin (a faithful housekeeper whom Lautrec's mother appointed to keep an eye on her son) reveals how ill the artist was. In a letter to Adeline Cromant, another servant of the family, Sarrazin writes:

> This morning Monsieur is still in an awful mess. He had me take 6 bottles of wine to Calmése's. I went to the wine merchants; he was sitting with two dirty sluts. That pig Calmése, they should put him in jail. He's going to be the death of poor Monsieur.[50]

And in a letter to Lautrec's mother, noting that "he still drinks a little":

> As long as he goes to Calmése's, it will always be the same. If there were some way of stopping him (. . .) It's true that Monsieur hasn't anyone else. You never see any of his friends anymore.[51]

In late February or early March Lautrec's mother had him confined for treatment in an asylum at Neuilly. He was visited there by Misia Natanson, but Bonnard and Vuillard were refused admittance when they attempted to see him.[52]

Lautrec was pronounced cured after a month's confinement, and released. The "cure", unfortunately, did not last long. "I can only interpret his drunkenness," remarked Vuillard many years later, "as a deliberate act of suicide."

> He dreaded being alone. His friendship was tyrannical and brooked no obstruction. Few men were more genuinely liked, by the way. Poor Lautrec! I went to see him one day in the rue Fronchot, just after he had been put in a home in Neuilly. He hadn't long to live. He was a dying man, a wreck. His doctor had told him to "take exercise," so he had bought a gymnasium-horse—he, Lautrec, who couldn't even get his feet on the pedals! A cruel irony—and yet it symbolized his whole life.[53]

In April of 1901, Lautrec returned to Paris for the last time to sort his paintings and other belongings. He died on September 9 of that year at Malromé in the south of France.

Conclusion

> In its early demonstrations the avant-garde remained a true community, loyal to itself and to its time. To a greater extent than at any time since the Renaissance, painters, writers and musicians lived and worked together and tried their hands at each other's arts in an atmosphere of perpetual collaboration.[54]

Nowhere was this "atmosphere of perpetual collaboration" more evident than in the circle of the *Revue Blanche*. Although perhaps somewhat less eclectic in its artistic than in its literary tastes, the review, nevertheless, espoused no single school of painting. It was more an *esprit* than a style that united its intimates.

There was, J. B. Jackson writes, something of "the spirit of the boulevardier" about the *Revue Blanche*.

> It assured the review of contact with the world, with *le Tout-Paris,* so that the directors and editors were always up to date on everything that happened. It was the life of Paris that unceasingly erupted around the *Revue Blanche . . .* which enabled it to retain "that Parisian equilibrium between . . . art and anarchy which she maintains smilingly, even impertinently, on the corner of the boulevard."[55]

All four of the artists discussed here shared in some degree a fascination with contemporary Parisian life. In Lautrec's depictions of brothels and cabarets, Vallotton's woodcuts of anarchist demonstrations, Bonnard's street scenes and Vuillard's quiet, middle class interiors, we sense the life of *fin-de-siécle* Paris. These four and their fellow artists brought to the *Revue Blanche* "prints, designs and posters to illustrate the inexhaustible flow of their conversation and their personalities," and in so doing "helped orient and enrich the spirit of the review itself."[56]

Bret Waller

FOOTNOTES: Artists and the *Revue Blanche*

1. Maurice Denis, "Définition du Néo-Traditionnisme," *Art et Critique* (August, 1890), reprinted in *Theories, 1890–1910,* 3rd ed. (Paris: 1913) p. 10.
2. Former Lycée Condorcet students who became Nabis were: Paul Sérusier, Maurice Denis, Ker-Xavier Roussel and Edouard Vuillard.
3. In 1894 the *Revue Blanche* moved from these quarters into new offices designed by the Belgian Art-Nouveau architect Henri van de Velde, at 1 Rue Lafitte, near the galleries of contemporary art dealers Durand-Ruel and Ambroise Vollard.
4. Russell, *Vuillard,* p. 99.
5. Charles Chassé, *The Nabis & their Period,* trans. Michael Bullock (New York: Frederick A. Praeger, 1969) p. 10.
6. Ibid., pp. 9–14.
7. Aurélien Lugné-Poë, *Le Sot du tremplin* (Paris: 1931) quoted in Russell, *Vuillard,* p. 80.
8. Russell, *Vuillard,* p. 27.
9. Andrew Carnduff Ritchie, *Edouard Vuillard 1868-1940* (New York: Museum of Modern Art, 1954) p. 23.
10. Stéphane Mallarmé, "Résponse a une Enquête," (1891) reprinted in Guy Michard, *La Doctrine Symboliste (Document)* (Paris: 1947) p. 74.
11. Robert T. Neely, "Endymion in France: A Brief Survey of French Symbolist Poetry," *Les Mardis: Stéphane Mallarmé and the Artists of his Circle* (Lawrence, Kansas: The University of Kansas Museum of Art, 1965) p. 30.
12. Ritchie, *Edouard Vuillard,* p. 96.
13. Russell, *Vuillard,* p. 32.
14. André Chastel, *Vuillard: 1868–1940* (Paris: Floury, 1946) p. 22.
15. Gold and Fizdale, *Misia,* p. 68.
16. Edouard Vuillard, letter dated July 20, 1897, reprinted in *Félix Vallotton, Documents pour une biographie et pour l'histoire d'un oeuvre,* 3 vols., Gilbert Guisan and Doris Jakubec, eds. (Lausanne-Paris: La Bibliothèque des Arts, 1973) 1:56.
17. Thadée Natanson, "Vuillard as I Knew Him," *Peints à leur tour* (Paris: Albin Michel, 1948) reprinted in Russell, *Vuillard,* p. 105.
18. Russell, *Vuillard,* p. 68.
19. Germain Bazin, "Vuillard Remembers Lautrec," *L'Amour de l'Art* (April, 1931) reprinted in Russell, *Vuillard,* p. 102.
20. Chassé, *The Nabis,* p. 124. See also Lugné-Poë quoted in Russell, *Vuillard,* p. 84.
21. Denis's term for the Nabis.
22. Lugné-Poë quoted in Russell, *Vuillard,* p. 80.
23. Bonnard's priority was questioned by Jean Adhémar (Francis Jourdain and Jean Adhémar, *T-Lautrec* [n.p.: Editions Pierre Tisné, 1952] p. 63). However, Bouvet cites a letter from Bonnard to his mother as evidence that his poster appeared at the end of March, 1891 (Francis Bouvet: *Bonnard, The Complete Graphic Work,* trans. Jane Brenton, intro. Antoine Terrasse [New York: Rizzoli, 1981] p. 12). Lautrec, in a letter to *his* mother dated October, 1891, wrote, "My poster is pasted today on the walls of Paris and I'm going to do another one." (Lucien Goldschmidt and Herbert Schimmel, eds., *Unpublished Correspondence of Henri de Toulouse-Lautrec* [London: Phaidon Press Ltd., 1969] p. 134).
24. Quoted by Monroe Wheeler, *Bonnard and his Environment* (New York: Museum of Modern Art, 1964) p. 16.
25. John Rewald, *Pierre Bonnard* (New York: The Museum of Modern Art, 1948) p. 30.
26. Paul Boucher, *Moniteur des Arts* (Paris: May 15, 1885) quoted by Guisan and Jakubec, *Félix Vallotton,* p. 225.
27. Chassé, *The Nabis,* p. 124.
28. Ashley St. James, *Vallotton graveur,* trans. Françoise Sotelo (Paris: Sté Nlle des editions du Chêne, 1979) p. 25.
29. Jourdain and Adhémar, *T-Lautrec,* Appendix, p. 106.
30. St. James, *Vallotton graveur,* p. 13.
31. Thadée Natanson, *Revue Blanche,* "Expositions," n.s. 4 (1893): 271.
32. Acording to Louis Godefroy, Vallotton learned the woodcut technique from Charles Maurin who had learned it in turn from Emile Bernard (Louis Godefroy, *L'Oeuvre gravé de Félix Vallotton* [Paris-Lausanne: 1932] p. 11). However, Maxime Vallotton, nephew of the artist, writes: "Who initiated Félix Vallotton to wood engraving? Three versions are known: Meier-Graefe quotes Auguste Lepère, Wellis talks of Jasinski and L. Godefroy of Maurin . . ." M. Vallotton suggests that his uncle may have been self-taught, inspired by Japanese prints, (Smithsonian Institution Traveling Exhibition Service, An Exhibition of *Prints and Drawings by Félix Vallotton,* preface by Maxime Vallotton [Traveling Exhibition Service of the Smithsonian Institution, 1971) n.p.
33. Octave Uzanne, "La renaissance de la gravure sur bois—un néo-xylographie: M. Félix Vallotton," *L'Art et l'Idée* (February, 1892) reprinted in Guisan and Jakubec, *Félix Vallotton,* p. 263.
34. Thadée Natanson, "De M. Félix Vallotton," *Revue Blanche* (Jan. 1, 1899) quoted in Guisan and Jakubec, *Félix Vallotton,* pp. 253–55.
35. *Ibid.,* p. 156.
36. *Ibid.,* p. 164.
37. Proust, *Remembrance,* 1:205.
38. Guisan and Jakubec, *Félix Vallotton,* p. 289.
39. Ritchie, *Edouard Vuillard,* p. 18.
40. Germain Bazin, "Vuillard Remembers Lautrec," interview in *L'Amour de l'Art* (April, 1931) reprinted in Russell, *Vuillard,* p. 102.
41. Charles F. Stuckey and Naomi E. Maurer, *Toulouse-Lautrec: Paintings* (Chicago: The Art Institute of Chicago, 1979) p.18.
42. Bazin, in Russell, *Vuillard,* p. 102.
43. Roger Shattuck, *The Banquet Years: The Origins of the Avant Garde in France 1885 to World War I,* revised ed. (New York: Vintage Books, 1968) p. 23.
44. For a discussion of chronology see note 23.
45. M. G. Dortu, *Toulouse-Lautrec et son oeuvre,* vols. 5-6 (New York: Collectors Editions Ltd., 1971). From 1894: D.3.616; from 1895: D.3.834, D.3.874, D.3.945, D.3.946; from 1896; D.4.286, D.4.296. Most of these drawings were owned by Thadée Natanson and came on the market at auction in 1953.
46. Thadée Natanson, *Peints à leur tour* (Paris: Albin Michel, 1948) pp. 268–69.
47. Gold and Fizdale, *Misia,* pp. 53–55.
48. *Ibid.,* pp. 57–58.
49. Guisan and Jakubec, *Félix Vallotton,* p. 156.
50. Goldschmidt and Schimmel, eds., *Unpublished Correspondence,* p. 252. Calmése, owner of livery stable, had become Lautrec's drinking companion.
51. *Ibid.,* p. 253.
52. Gold and Fizdale, *Misia,* p. 67.
53. Bazin in Russell, *Vuillard,* p. 105.
54. Shattuck, *Banquet Years,* p. 28.
55. Jackson, *Revue Blanche* (incorporating a quotation from Robert de Souza, *Mercure de France,* [Dec., 1896) p. 593.
56. Jackson, *Revue Blanche,* p. 73.

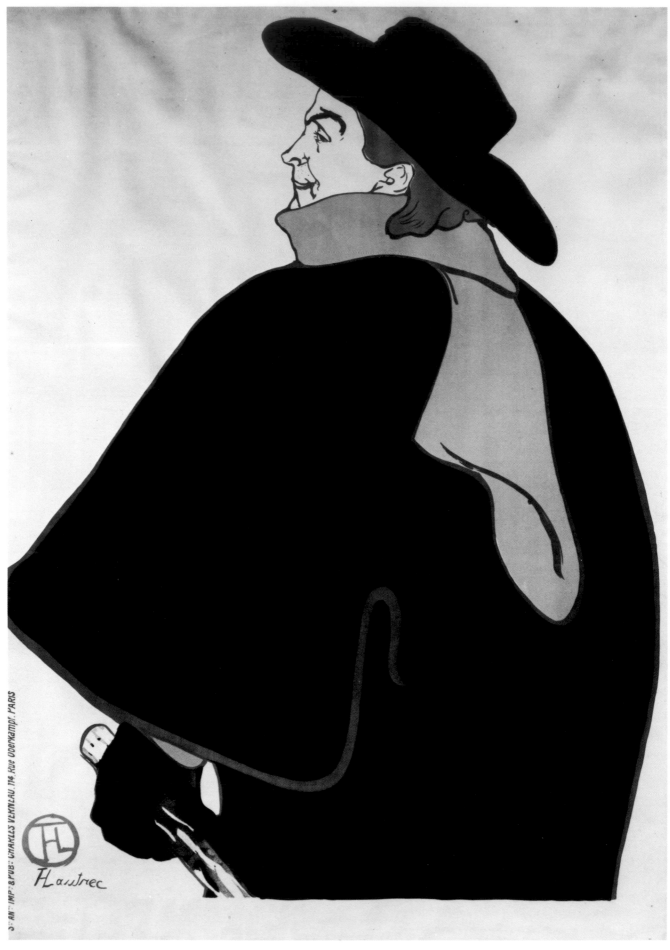

Cat. No. 27

27. **Henri de Toulouse-Lautrec (1864–1901)**
Aristide Bruant in his Cabaret, 1893
color lithographic poster
Delteil 348 $^{1}/_{ii}$
50 x 36⅞ in. (1270 x 925mm)
From the collection of Mr. and Mrs. Herbert D. Schimmel

THE ARTISTS OF THE REVUE BLANCHE AND THE 1890S

In retrospect, the decade of the 1890s seems very much a time of transition. The optimism, materialism and preoccupation with a comfortable middle-class way of of life, which was characteristic of much of the nineteenth century, predominated, but was challenged by many undercurrents which seem fundamental to a twentieth-century outlook. A faith in science and progress coexisted with a sense of disillusionment with existing modes of thought and a probing of new avenues including the occult and the unconscious. In the arts, ideas which seem fundamental to the twentieth century, like an interest in the expressiveness of formal elements in their own right, in multivalent symbols, in the way in which the different arts approach one another, and other concerns in which abstraction is rooted, interacted with nineteenth-century naturalism and assumptions about subject matter. In politics in France it was a time of relative stasis, disrupted by anarchist demonstrations and the Dreyfus affair, but without the major upheavals or economic crises which had characterized earlier decades in the nineteenth century or which would be faced in the twentieth century.

It was a rich time. Roger Shattuck has referred to these years before the First World War as the "banquet years," not only because people celebrated their friendship and their enthusiasm for individuals or causes in festive gatherings, but also because a splendid variety of artistic movements and personalities was available.[1]

It was a time when art, literature, politics and other intellectual currents were intertwined. Artists and writers not only knew each other and discussed one another's works; they collaborated. Critics felt at home with literature, art and politics. Félix Fénéon, a poet and critic who edited the *Revue Blanche* for many years, was an anarchist, as were some of his Neo-Impressionist friends. Monet was a friend of the politician and future premier Clemenceau. Artists and writers were among the most ardent supporters of Dreyfus. The barriers between different art forms were often broken down in theatrical performances.

The *Revue Blanche* reflected the special complexity of this period. It covered literature, the arts, politics and events in Paris with an emphasis on what was new, but without any special ideological leanings (except for its leftist politics) or fostering of one direction over another. In so doing it gives us a picture of a decade in which many things, which we tend to think of as chronologically separate, were going on at the same time.

If so-called "Post-Impressionism" seems in retrospect to have dominated in the 1890s in the works of Gauguin, the Nabis—including Bonnard, Vuillard and Vallotton—and Toulouse-Lautrec, Impressionism was far from dead. The term "Impressionist" was used by artists and galleries to designate advanced art. Works by the older artists were shown, sometimes in combination with those by younger artists, and were admired by artists and critics alike. Monet's series, Degas's later dancers and bathers, Renoir's figures, Pissarro's more decorative late landscapes and Cézanne's landscapes, still lifes and figure paintings are all works of the 1890s which had special qualities, some of which were explicitly singled out by the *Revue Blanche*. Similarly, if symbolist directions in poetry and drama seemed to be on the ascendency, Zola and naturalism were very much alive and were acknowledged in the periodical.

The *Revue Blanche* is remembered primarily for its association with French art and letters, but its eclecticism extended to many other realms including politics, the occult, cycling, mathematics and history. It was also an important vehicle for the introduction of Scandanavian literature to France and included other foreign writings (Fénéon translated Jane Austen's *Northanger Abbey* and portions of Tolstoy's theoretical writings were published). It also devoted attention to Japanese prints, the works of Edvard Munch and other foreign art.

The diversity which was characteristic of the *Revue Blanche* was in one way an expression of the richness of the times; it was also an indication of the lack of a clear sense of direction. As in the 1970s in New York, the pluralism in art in the 1890s in Paris would provide many possibilities for the future but gave people at the time no feeling of conviction about the leading style or true direction. It was in such a context that a periodical which depended very much on individual personalities could thrive.

The Parisian and bourgeois character of French art in the 1890s and the exuberance and ferment and interaction of personalities which were part of the art scene, were evident in the *Revue Blanche*. In its attention to a full spectrum of events and phenomena, it satisfied an urban audience which was pleased by its particular brand of sophistication and humor. The personalities involved in the production of the periodical were reflected in it.

The audience for avant-garde art and the group which produced and read the *Revue Blanche* were relatively well-off, well-educated people, who lived in Paris for the most part. This city was the center for artistic and literary activities, and the *Revue Blanche*'s success depended in part upon its identification with the Parisian milieu in various ways. It was one of a number of small journals, with circulation in the thousands, which were read by a group of people who, like the Natansons, went to openings of exhibitions and to the theatre and liked to feel a part of the scene. The *Revue Blanche* devoted a good portion of each issue to things going on in Paris, for its readers wished to keep up with what was current.

The review participated in the Parisian scene in more direct ways. Its offices were located just off one of the great boulevards which, with the rebuilding of Paris according to Baron Haussman's plan, had become the focus for fashionable social interchange. The offices were also near the major art dealers' galleries. They became a place where men of literary and artistic tastes, and even women like Misia Natanson, could drop in and continue the kind of discussion they had in the cafes of the boulevards. The *Revue Blanche* had an open house on Thursdays, but people came at other times, and sometimes stayed into the evening. It also played an active part in the Parisian art scene in several ways. Besides the prints it commissioned to be included in the magazine, it extended its presence in Paris through posters, like those by Bonnard (cat. no. 10) and Toulouse-Lautrec (cat. no. 40) which made its association with avant-garde art clear. It also held some small exhibitions in its offices.

The imagery of the artists connected with the *Revue Blanche* was closely associated with Paris of the time. Although these artists continued the Impressionists' concern with subjects from modern life and bourgeois leisure, with an emphasis on aspects of the artists' own experience, the particular direction given to these subjects by Vuillard, Bonnard, Vallotton and Toulouse-Lautrec reflected their connection with a social milieu that was shared by the producers and readers of the *Revue Blanche.*

Both Vuillard and Bonnard show outdoor contexts in which aspects of the social life of the time took place. The boulevards where people promenaded, sometimes with their pets, to show off their fashionable clothes, to see and to be seen, figure in a number of Bonnard's and Vuillard's paint-

Cat. No. 16

ings and prints (cat. nos. 14, 15, 16). Both also showed gardens, sometimes private, but sometimes the public gardens, like the Tuileries, where such activities also went on. (The boulevards, of course, were also locations for advertising, which the *Revue Blanche* artists undertook (cat. no. 68)). Vallotton, in his views of the Parisian streets, shows a fuller range of people and demonstrates an awareness of the disrupting events of the time which play no part in the serene, though sometimes slightly satirical, pictures of his colleagues (cat. nos. 56, 59, 60, 67).

Other aspects of public pleasures are evident in the works of these artists. Toulouse-Lautrec, especially, devoted himself to scenes of entertainment. Unlike the more neutral Impressionist works which formed his precedent, his views of entertainers project a strong sense of personality and knowledge of the individuals involved, and a sophisticated and somewhat jaded attitude toward the illusions they created (cat. nos. 27, 33, 37). Like Vuillard and Bonnard, he also contributed directly to the theatre through programs.

The *Revue Blanche* had an accent on personality and individualism. In the first issue of the new (Parisian) series, the statement on the aims of the periodical, by the editor Lucien Muhlfeld, said, "We wish to develop our personalities and it is to determine them through their complementaries of sympathy and admiration that we respectfully solicit our

77. **Edouard Vuillard (1868–1940)**
 The Luncheon (*Le Dejuner*), c. 1895–97
 oil on cardboard
 15¾ x 13¹³⁄₁₆ in. (400 x 351mm)
 Yale University Art Gallery
 The Katherine Ordway Collection (1980.12.17)

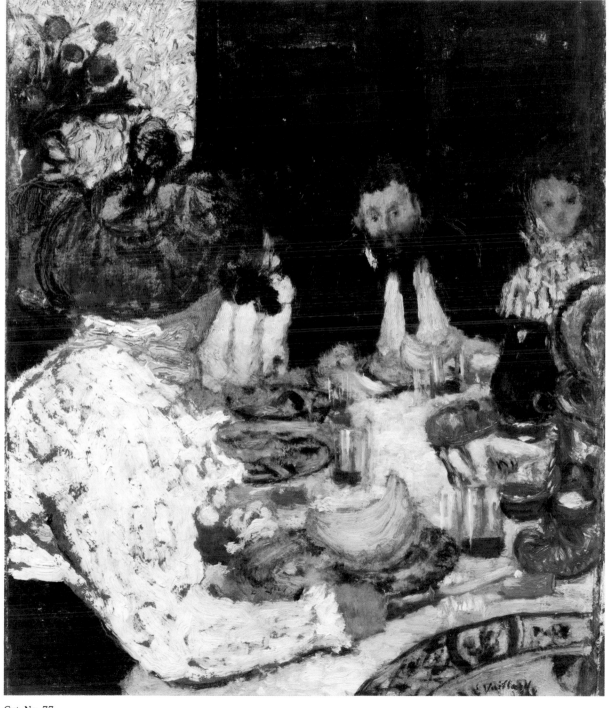

Cat. No. 77

25. **Henri de Toulouse-Lautrec (1864–1901)**
Sagesse, 1893
lithograph
Delteil 22 ¹/ᵢᵢ
10 x 7½ in. (254 x 190mm)
From the collection of Mr. and Mrs. Herbert D. Schimmel

masters and welcome the young gladly."[2] The notion of something in progress was basic to the *Revue Blanche,* the more so since its editors and contributors were, in many cases, very young men who were in the process of discovering themselves.

The idea of personality went much further, however; members of the *Revue Blanche* circle cultivated social personas which affected their roles as artists or connoisseurs. Thadée and Misia Natanson not only made a point of appearing at openings and other artistic events, they also ran a sort of salon, presided over by Misia. According to her own memoirs and witness accounts she combined genuine musical talent and an appreciation of the arts with ambitions to be a social arbiteur and *femme fatale.* Vuillard, Bonnard and Vallotton were relatively quiet participants in the Natanson circle, and the glimpses they give to us of this world convey a sense of ease and comfort (cat. nos. 5, 77, 78). Toulouse-Lautrec, on the other hand, felt himself an outsider because of his physical deformities and committed himself neither to the aristocratic circle to which he belonged by birth, nor to the colorful, but bourgeois, circle of the Natansons. His interactions with this set tended to be flamboyant. He sometimes looked at Misia and other members of the circle, like Coolus, the drama critic, with a caricaturist's eye (cat. nos. 25, 43) and is reported to have served such imaginative and lethal cocktails at a party that he was the only one left standing at its end.[3] The persona of an outsider who spent his time in night clubs and brothels informed much of his art. Like his collaborators on the satirical "Chasseur de Chevelures" (scalp hunter) or the supplement "NIB" in the *Revue Blanche,* he did not distinguish between personalities and performances or actions.

The accent on personality in the 1890s found one kind of expression in a number of groups to which artists and writers belonged and in which discussions ranged over the kind of varied topics which the *Revue Blanche* covered. Some of these associations, like the Nabis (of which Bonnard, Vuillard and Vallotton were members) and the Rose + Croix (or Rosicrucians) were, initially at least, connected with the decade's interest in phenomena beyond mundane daily reality. They had special names and rituals at their meetings. Some of the Nabis, like Denis, pursued religious themes in their art, but others, like Bonnard, Vuillard and Vallotton, seem to have profited from the philosophical discussions and

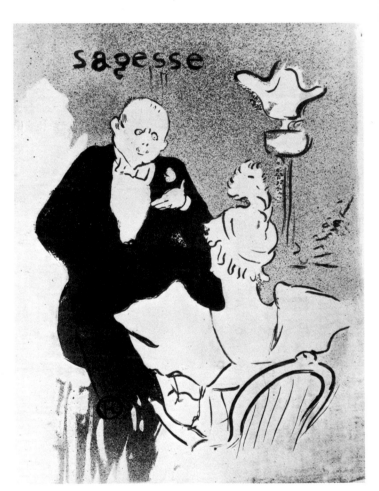

Cat. No. 25

artistic innovations of the group—its emphasis on the picture as an arrangement of forms and colors on a flat surface, for instance—and enjoyed the social contact without taking spiritual concerns seriously.

Despite some attention to historical religious matters in the *Revue Blanche,* Thadée Natanson remained skeptical of the brand of religious art and medievalism purveyed by the Rose + Croix under their charismatic leader, Sâr Peladan. In 1896 Natanson characterized them as "desperate for attention" and wrote of the "pitiable idealism proclaimed by the pitiable realizations" shown in their salon.[4] If the Rose + Croix's pretensions irked Natanson it may well have been because he understood the dynamics of such groups.

The Natanson's circle was another example of a social group, with artistic overtones, which was presided over by a dominating personality, but one of its members, the poet Mallarmé, had a more famous and influential group clustered around him. His Tuesdays attracted writers in the *Revue Blanche* circle like Pierre Louÿs, Andre Gide, Paul Valery, Gustave Kahn and Camille Mauclair as regular visitors. Other associated with the periodical came from time to time: Fénéon, Oscar Wilde, Maeterlinck, Verhaeren, Debussy as well as Vuillard, Gauguin and Redon. At these occasions Mallarmé talked. An admirer reported that a sense of mystery and poetry came from the master himself and his small apartment. Mallarmé was an enthusiast for the dance and for the paintings of the Impressionists. He also revealed his ideas on art. For Vuillard and other young artists who attended his evenings the message was one of indirectness. In 1892 Mallarmé said, "One must not translate things in themselves and directly (they are more beautiful in nature) but look at them indirectly and suggest them."[5]

Another tacit message of Mallarmé's was the smallness and interconnectedness of the world of the arts in the 1890s. Mallarmé was a pivotal figure and had an extraordinarily wide network of contacts. He knew major literary figures, the Impressionists and other artists of their generation as well as younger artists, performers and people in government. He wrote for the *Revue Blanche* and other journals. Mallarmé was unique, but he was not alone in knowing almost everyone and in integrating social activities with his interest in the arts.

Beneath the apparent calm and optimism of the 1890s there were a number of indications of fundamental changes in attitude toward the arts and society which the *Revue Blanche* and artists associated with it reflected. These included shifts in the way art was shown and sold, and challenges to bourgeois values.

In the first part of the nineteenth century, the arts were directed through a centralized administrative body which controlled education and performances or exhibitions. The official Salon was the chief means for artists' works to become known and to find buyers. Initially the taste of its juries had been in line with that of creative artists of the day and with that of the public, but a growing number of artists from the 1870s onward found the juries too conservative and began holding their own exhibitions. The 1880s and especially the 1890s saw a flowering of exhibitions outside of the official Salon, and even reform within the system itself, with the institution of more than one exhibition and an unjuried Salon of Independents. The reasons for this were multiple. The government had ceased to be the chief patron of the arts and could no longer exert such stringent control. The growing prosperity of the middle class provided a larger pool of potential patrons, including some willing to buy avant-garde art. The Academy of Fine Arts and the official Salons maintained a conservative stance which did not represent the full range of artistic activity, and, perhaps more important, which upheld standards no longer backed by absolute conviction.

J. E. Blanche, writing in the *Revue Blanche* on the Salon of the Champs-de-Mars in 1895, articulated a feeling about art which was also an expression of larger currents in the 1890s. He contrasted his own time with great periods in art when no one tried to be different and in which variations occurred naturally as artists followed the formula of the day.

> It is perhaps that nothing resembling a style can yet issue from such numerous attempts in all directions, from these feverish fumblings of "personal endeavor." Individualism, in these days of universal anarchy, reveals itself as the declared enemy of "style."[6]

Blanche was writing about objects, which is in itself an indication of the breaking down of boundaries between categories in the 1890s. The *Revue Blanche,* in covering many kinds of exhibitions, but in taking no ideological stance, acknowledged and supported individualism.

Another feature of the art scene which the *Revue Blanche* acknowledged in its reviews was the system of

private exhibitions held by art dealers. Although dealers had long shown works, and artists had put on exhibitions, often with the intention of raising money for one cause or another, the system came into its own during the 1880s. In the latter part of this decade there were about 112 picture dealers in Paris, mostly situated in the Opera district. Twenty-two were on rue Lafitte, where the *Revue Blanche* had its offices.[7] Just as the *Revue Blanche* and other little magazines arose from a situation where multiple points of view were possible, dealers responded to the possibility of multiple points of view in the showing of art because of a growing public interest and support for new directions.

A glance at the calendars or reviews of events in Paris in periodicals like the *Revue Blanche,* or some of its rivals like the *Mercure de France,* (which had an especially full coverage) in the 1890s, reveals an almost bewildering array of exhibitions. The *Revue Blanche* acknowledged the presence both of the older, established institutions and artists, and the independent groups and dealers in its reviews, thereby suggesting the legitimacy of new movements, but without making any statement about their superiority.

Implicit in Thadée Natanson's treatment of the Salons, however, was a sensitivity to changes in institutions. In reviewing the Salon des Indépendants in 1896 he mentioned that it was threatened because people had sent fewer things and the overall quality was lower, despite the presence of several artists whose work he admired. He wrote that the other two Salons had medals, government purchases, rubrics in journals and attracted the interest of couturiers and hat makers (that is, people of no particular status or culture). The Independents, by inviting everyone, excited no one's desire. He felt that the fashion was for private exhibitions, which were more adaptable than ones which showed only innovators or intransigents.[8]

The Louvre remained part of the art scene. The *Revue Blanche* noted that it had been rationally rehung, with paintings grouped by schools and separated so that the frames no longer touched.[9]

Special exhibitions of many types were held. Artists who had died recently, or whose centennial it was, or who simply seemed to deserve a retrospective, like Meissonier, Corot and Manet, were featured in shows. (Manet received an extended discussion in the *Revue Blanche* in 1897). The Ecole des Beaux-Arts, recognizing modern enthusiasms, held a major exhibition of Japanese prints in 1890 which interested Bonnard and Cassatt, among others. There were many Circles and Societies—Pastellists, Artistic and Literary, Women—and many affinity groups—the Bretons of Paris, French Orientalist painters. There were also groups which assembled under an artistic designation; the Neo-Impressionists had several shows at Durand-Ruel and there were several annual Exhibitions of Impressionist and Symbolist painters at Le Barc de Boutteville's gallery, featuring many unfamiliar names.

Although in its commissions for prints the *Revue Blanche* supported younger artists like Vallotton, Vuillard and Bonnard, Natanson wrote admiringly of the Impressionists, who he felt were entering into history. Durand-Ruel was a long-time champion of the Impressionists, and Natanson praised his exhibitions as providing a sense of relief in the confusion of the Parisian scene.

> It is to be hoped that this fashion which M. Durand-Ruel seems to have inaugurated, will be continued—of inviting the *amateurs* to at least one important exhibition each year, of one of those artists who can only be seen in his galleries. It's necessary to choose the time; ones' attention, dispersed by the quantity of disparate objects hung each spring revives in front of the unity of a beautiful harmonious effort; the eyes, tired and wounded by the general mediocrity, repose deliciously and rejoice in the painting.[10]

Through the 1890s, Monet, Pissarro, Renoir and Morisot had exhibitions at intervals. Redon, who had not been shown in this way before, had a major exhibition in 1894 which was a revelation for many younger artists and confirmed his position as an innovator in symbolist directions. He was the only artist of his generation to be invited to make prints for the *Revue Blanche.*

Vollard, another dealer who showed both younger and older artists, had a major exhibition of the work of Cézanne in 1895; it was the first one-man show for this artist. Natanson spoke of the influence this artist already had had and of his mysterious allure as if it were the call of the future.[11]

To a certain extent, Thadée Natanson's approach as a critic was that of an *amateur.* He visited exhibitions as part of his daily life and looked with the discerning eye of one who loved art and collected it, but had no allegiances. When

he reviewed an exhibition, he often gave a sense of how the totality felt and then went on to discuss aspects of the works shown. Rather than presenting an argument or an approach to the work of the artist in question, he mentioned features which interested him, whether they had to do with the personality of performers portrayed by Toulouse-Lautrec, or the disturbingly rough *facture* of Monet's Cathedrals or the solidity of forms in Cézanne's landscapes or Bonnard's taste and care in composition. His comments are those of a cultivated gallery goer, but one with an uncanny eye for artists whose works are admired today. Out of the variety of shows in Paris he chose most often to discuss those by artists who have not disappeared into oblivion.

Thadée Natanson was a patron of art as well as a critic. He commissioned many works of art from the artists who surrounded the *Revue Blanche,* including portraits of Misia and decorations for their apartment. His friends were also inspired to commission decorations. Undoubtedly Natanson played an important part in the decision of the *Revue Blanche* to take an active role in commissioning prints and posters and in holding small exhibitions in its offices of the works of its artists.

Natanson's criticism frequently acknowledged that art could be considered a commodity in the 1890s, and that easel painting was being challenged as the primary form for works of art. The art nouveau movement produced furniture, interior designs, objects for domestic use and even clothing based on aesthetic principles. Exhibitions of these objects, which shared the curvilinear forms characteristic of much of the art of this period, were favorably reviewed in the *Revue Blanche.* In 1896 Natanson discussed such a show with reference to the idea of art following the needs of society. He wrote of the vast stores, selling objects and furniture, which had recently opened under the banner of art nouveau. He mentioned that there was a poorer, more numerous clientele for whom objects should be provided which were less expensive and derived their ornamental value not from the materials but from the quality of the proportions of their forms. Without mentioning any names, he said that some of the most gifted young artists seemed more preoccupied with ornamenting a house or a utensil than with finishing a statuette or an easel painting.[12]

Edmond Cousturier, who also wrote for the *Revue Blanche,* reviewed an exhibition at the galleries of Samuel Bing, a dealer significant both for Japanese art and art nouveau. He criticized Bing for giving an important place to paintings, pastels, watercolors, drawings, prints and small sculpture. "To sell framed things at the same time as furniture and hangings which are beautiful in themselves seems a contradiction; it favors the old error which consists in peopling walls with little frames."[13]

Prints represented one alternative to easel paintings. They were cheaper than oil paintings and were not unique; thus they could have a wider distribution than individual works. They did not need to be displayed on walls. Sets were often issued as periodicals or in books, or were kept in portfolios. Some ventures in the 1890s were a synthesis of art and publishing and advertising.

Beginning in 1893, the *Revue Blanche* commissioned prints from Vuillard, Bonnard and others, including Redon and many of the Nabis, for its frontispieces (cat. no. 62). It published these prints separately in an album. Other artists, Vallotton above all, but also Toulouse-Lautrec and Bonnard, did illustrations for articles, poems and stories, or made decorative vignettes which appeared with headings or at the ends of articles.[14] In addition, the *Revue Blanche* commissioned posters from Toulouse-Lautrec and Bonnard (cat. nos. 10, 40). By publishing original prints the periodical further broke down the boundaries between the work of art as a precious object and the work of art as something in the environment which enriches ordinary life.

The end of the nineteenth century was a time of great innovation in printmaking, especially in color lithography. Toulouse-Lautrec played a seminal role in the transformation of the color print from its association with commercial chromolithography and conventional advertising to something truly creative.[15] He was not alone, however, in making works which often had a practical commercial purpose and yet were admired and collected for their forceful imagery and inventive use of the medium. Dealers who specialized in prints, posters and illustrated books sprang up (cat. no. 57). Established dealers, like Durand-Ruel, began to hold exhibitions of works by painter-printmakers—artists whose primary activity was not printmaking. Vollard, another important dealer, inspired by the success of the serial *L'Estampe originale* (to which some of the *Revue Blanche* artists had contributed prints) (cat. no. 36) commissioned prints for an album of painter-printmakers from some of the

same artists in 1896, and also commissioned both individual prints and sets. Bonnard's *Quelques aspects de la vie de Paris* (completed in 1895) (cat. nos. 14, 15), his cover and poster for the second collected album and works by Bonnard, Denis, Vallotton, Vuillard and others published in these albums, indicate Vollard's interest in the circle of artists connected with the *Revue Blanche*[16] (cat. nos. 67, 106, 107, 108).

Prints had qualities which made them appropriate vehicles of expression for artists interested in directions other than sheer naturalism. The full range of hues in oil paints, their luminosity and their ability to create varied textures through brush strokes all enhance the artist's capacity for illusion. The print, however, demands that the subject be translated into a linear medium. Lithography provided a way to create an equivalent to the flat colored shapes, which many artists admired in Japanese prints, and to further the exploration of pattern which delighted the Nabis. Increasingly as artists like Toulouse-Lautrec used lithographic ink (tusche) with a brush, or spattered it (cat. nos. 20, 29), effects peculiar to the combination of greasy lithographic crayon or ink and the stone onto which it was applied became part of the effect of the print. This was analogous to the function of the texture and surface of Vuillard's and Bonnard's oil paintings on board (cat. nos. 6, 77), or Lautrec's pastels. The coordination of lettering with figurative·elements, as part of the overall design, was another anti-illusionistic and innovative feature of many prints, especially posters and theater programs (cat. nos. 10, 20, 26).

Little magazines, the commercial sale of prints and objects, and private exhibitions represented a challenge to standard methods for the presenting and judging of art. The official institutions would remain, but their authority had been eroded. In a similar way, little magazines, and artists and writers associated with the avant-garde challenged assumptions about the conduct of modern life, especially relations between the men and women and between dissidents and authorities.

Outwardly accepting of bourgeois morality, many of the journals, plays, pictures and songs of the time, even those directed to a relatively unsophisticated middle-class audience, dealt with its failures. In some cases this was done in a light-hearted way. Adultery was a favorite theme in the established theater, as well as in plays put on at the Théâtre Libre and the Théâtre de l'OEuvre. Toulouse-Lautrec illustrated the

program for *Le Gage,* a play which concerned itself with a deceived husband who, knowing about his wife's affair, refused to comply with the demands of an extortionist (cat. no. 44). Aristide Bruant, whom Toulouse-Lautrec showed in imperious poses in posters for his cabaret (cat. nos. 21, 27), delighted his bourgeois audiences by insulting them in his songs full of street slang.

In other cases, the element of farce was missing. Both Vallotton and Toulouse-Lautrec dealt with the outwardly pleasurable, but not necessarily rewarding, interactions of well-dressed, often top-hatted, wealthy men, and women of the *demi-monde* (cat. nos. 22, 63). Toulouse-Lautrec's poster for the novel *Reine de Joie,* in which a middle-aged, balding man is being kissed by a seductive woman, promises no more happy an outcome than do the encounters in Vallotton's prints. The tone in Lautrec's works is not one of moral outrage; both sexes are caricatured. Vallotton's *Intimacies* (cat. nos. 69–72) are perhaps more disturbing, since they show the failure of relationships between middle-class people enacting the same rituals of romance which had long been the subject for writers and artists who accepted the idea of a happy ending. Vallotton's prints are disquieting because they show ordinary life in an ominous, or even cynical way.

Although related in sensitivity to design and in interest in the interior, works by Vuillard and Bonnard of the same time present more harmonious scenes (perhaps in some cases belying the tensions which would eventually break up the Natanson's marriage) (cat. nos. 6, 77, 78). Most of the figures in their interiors are seen in a neutral way; however, some of their other works, like Vuillard's program for *La Vie Muette* (cat. no. 100), show an awareness of the ways in which the formal aspects of the print could be used for expressive purposes. The play, put on at the Theatre de l'OEuvre, dealt with a lack of communication and comprehension between a husband and wife. As Toulouse-Lautrec had done in his program for *L 'Argent* (cat. no. 28), Vuillard used the physical separation of the figures to indicate the psychological distance which separated the characters. The blank space of the walk, like the table in Lautrec's print, emphasizes the disjunction.

Commentary on social institutions in the *Revue Blanche* was indirect, except in the case of politics; however, it published some articles in which these issues were discussed. In 1895 a translation of the Scandanavian play-

69. **Félix Vallotton (1865–1925)**
 The Lie (*Le Mensonge*), 1897–1898
 woodcut from *Intimités* series
 Vallotton and Goerg 188
 7¹⁄₁₆ x 8⅞ in. (179 x 225mm)
 The Museum of Modern Art, New York
 Gift of Abby Aldrich Rockefeller (by exchange) (191.54.1)

70. **Félix Vallotton (1865–1925)**
 The Cogent Reason (*La Raison probante*), 1897–98
 woodcut from *Intimités* series
 Vallotton and Goerg 191
 7 x 8¾ in. (178 x 223mm)
 The Museum of Modern Art, New York
 Gift of Abby Aldrich Rockefeller (by exchange) (191.54.4)

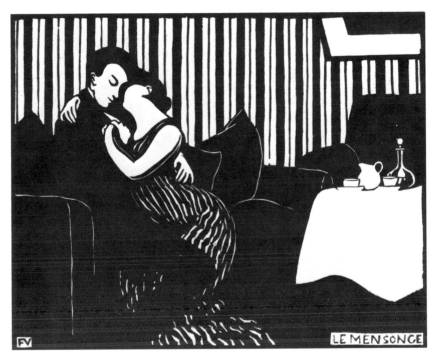

Cat. No. 69

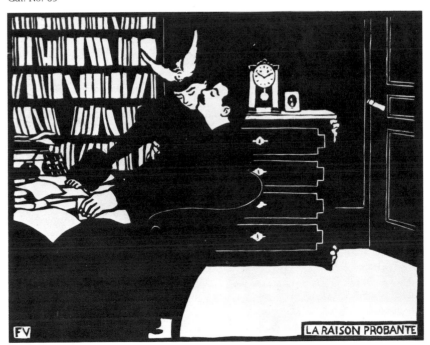

Cat. No. 70

71. **Félix Vallotton (1865–1925)**
Extreme Measure (*Le Grand Moyen*), 1897–98
woodcut from *Intimités* series
Vallotton and Goerg 193
7 x 8¹³⁄₁₆ in. (178 x 225mm)
The Museum of Modern Art, New York
Gift of Abby Aldrich Rockefeller (by exchange) (191.54.6)

72. **Félix Vallotton (1865–1925)**
The Other's Health (*La santé de l'autre*), 1897–98
woodcut from *Intimités* series
Vallotton and Goerg 196
7 x 8¾ in. (178 x 223mm)
The Museum of Modern Art, New York
Gift of Abby Aldrich Rockefeller (by exchange) (191.54.9)

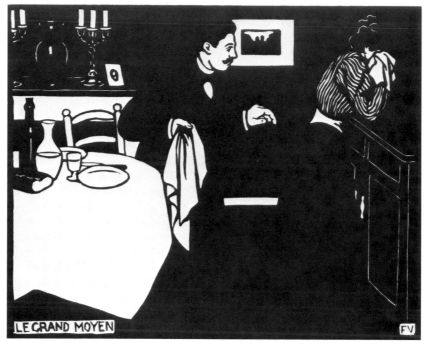

Cat. No. 71

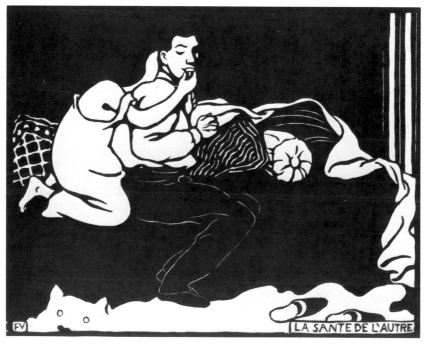

Cat. No. 72

wright Strindberg's essay on the inferiority of women appeared. In it he justified the subordinate situation of women, partly on physiological grounds.[17] On this, as on many other issues, the *Revue Blanche* did not fear the accusation of eclecticism.

Another side of the disruptions in social relations is evident in Vallotton's prints showing demonstrations and the forces which attempted to maintain order. In some prints, like the *First of January* (cat. no. 67), he showed economic inequalities which were a persistent feature of French life. In showing the arrest of an anarchist (cat. no. 56) he contrasted the large, grasping figures of the police to the small and youthful rebel. In most of his prints showing demonstrations, however, it is not clear what is going on. The well-dressed figures are knocked to the ground or flee in a visual evocation of the random disorder created by demonstrations in the early 1890s (cat. nos. 59, 60). Although the anarchists were much feared, demonstrations also occurred at the performance of Wagner's *Lohengrin* and other theatrical events, and Vallotton seems to have been more interested in their effect, and in the response of the police, than exploring the causes. In 1894, after the assassination of president Carnot, repressive legislation was passed. The soldiers and police in Vallotton's prints, while visually ordered in contrast to the chaos of the demonstrators, present an unflattering and almost faceless picture of the forces of law. As in his *Intimacies,* Vallotton presents a disturbing situation without placing blame or offering solutions. It has been suggested that the concentration on interiors in the art and literature of the 1890s can be seen as retreat from a chaotic outside world threatened by bombings and assassinations.[18] The decorative schemes created by Vuillard and others could produce a kind of haven, but Vallotton was witness to a more profound malaise which was also part of the world of the 1890s.

A sensitivity to the powers of expression in art apart from, or in addition to, subject matter was a pervasive characteristic of avant-garde art and criticism in the 1890s. In the 1880s Wagnerian ideas about art had become popular among artists and writers who welcomed the notion that boundaries between individual art forms could be broken down. Wagner's dream of the single work of art which combined all forms—in his case the opera—was connected to Baudelairean ideas of correspondence—that experiences in one sensory realm, or one art form, could evoke those in another—and with symbolist ideas of suggestion. Subjective and intangible experience could be expressed in different forms and media. Critics of the time compared paintings to poems and music. Thadée Natanson, in writing about Bonnard's work, evoked different sensory experiences:

> Sometimes the harmony is more raw, dull, violent, heady . . . or fresh and light . . . sometimes sharper, more acid. . . . Tranquil melodies or vibrant rhythms all attest to the same gift, whether they sing apart or whether their luxuriant symphony unites them in a composition as important as the large panel of greenery.[19]

Theater, like opera, could not merely evoke effects of different art forms, it could combine them. Avant-garde theater in the 1890s incorporated both symbolist ideas and progressive social and political views. The works of Ibsen, for instance, were favorites more for their mysterious qualities than for their social commentary, however, plays like *An Enemy of the People* and *The Pillars of Society* appealed to the anarchist sentiments of many members of the audience. The theater provided a means for collaboration among artists working in different art forms, including those with a concern for words, sound, movements and visual images.

The *Revue Blanche* covered the theater as part of its chronicle of events, but it also had many special ties with the theater. It published articles on Maeterlinck, the Belgian symbolist playwright, before his work was put on in France.[20] It reviewed the plays put on at the new Theatre de l'OEuvre.[21] It gave recognition to some alternatives to conventional theater like a marionette performance in which Ranson, Vuillard and Roussel participated and for which the audience included Mallarmé, Valéry, Mauclair and Debussy.[22] It led the way in recognizing Scandanavian authors, including Strindberg.

The Natansons took an interest in the theater. Alfred Natanson married the actress Marthe Mellot, a participant in some of Lugné-Poe's productions. Thadée and his wife Misia appeared regularly at the dress rehearsals which were the equivalent of opening nights. In one sense this was simply an aspect of their enthusiastic participation in the arts scene, but their enthusiasm for Ibsen led them to make a pilgrimage to Norway in the summer of 1894 with Lugné-Poe to meet the playwright and see his plays performed by Norwegian actors.[23]

In many ways the world of the theater in the 1890s was a microcosm of the world of the arts. It had a well-recognized, financially successful side, aimed at the bourgeoisie, who wanted the familiar, and who expected to have a good time. The state schools and theaters had evolved a highly conventionalized type of acting, which had institutional support in much the same way as academic painting did. As with the visual arts, standard repertory, subjects and styles were being challenged and alternative institutions were springing up in the later 1880s and 1890s.

The development of the avant-garde theater involved directions of both naturalism and symbolism. As with painting, there was no trend universally recognized as the most important, although by the mid-1890s, the realist theater had lost its creative energy. Whatever its ideological direction, the avant-garde theater fused diverse tendencies. Ideas were borrowed from exotic sources, like Japanese drama put on at the Exposition Universelle of 1889, marionette theater, mime, shadow puppets and other alternatives to the usual styles of presentation and acting. Foreign playwrights had a great success in the avant-garde theater, especially Ibsen, who was claimed both by the naturalists, who were the first to put on his plays, and by the symbolists. Lugné-Poe took a company of French actors to Norway to put on Ibsen's plays before the author himself, and got his approval.[24]

Both the naturalist and symbolist theaters transformed modes of presentation and acting styles, although in different ways. The Théâtre Libre, founded by André Antoine in 1887, was the most successful and significant institution in the avant-garde theater. It produced as many plays as all the others combined and was recognized as a rival of existing theaters. Antoine introduced a realist style of acting and presentation, which included such things as having actors stand with their backs to the audience, and using real sides of beef as part of the decor for a play called *The Butcher*. It was in a realist style that the first performance of a play by Ibsen, his *Ghosts* in 1890, and Strindberg's *Miss Julie* were presented.

Lugné-Poe also regarded sets and costumes as an integral part of the drama, but developed a very different mode of presentation. He minimized the personality of the actors and was interested in the expressive possibilities of a very static staging, with exaggerated gestures. As the Théâtre

Libre had achieved success, its identification with realist literature and its increasingly conventionalized acting style had led to demands for the formation of a "poets' theatre." This need was met first by the Théâtre d'Art and, after its demise, by Lugné-Poe's Théâtre de l'OEuvre, which was founded in 1893.

Artists had ties with the different theater groups. Antoine had artists design programs for his theater and pioneered in the use of color lithography for programs. Vuillard (cat. no. 86) and Bonnard (cat. no. 7) did watercolor designs for him. Unlike the later programs for the Théâtre l'OEuvre (which were mostly one color), which showed specific plays, those of the Théâtre Libre functioned in a more general way, identifying the theater with avant-garde art of the time. Paintings by Signac, Seurat, and Van Gogh hung in its lobby.

Through their close association with Lugné-Poe, with whom they had shared a "pocket-handkerchief-sized" studio in 1890, Vuillard, Bonnard and Denis became deeply involved with the Théâtre de l'OEuvre. It was Vuillard who contributed the name; he is reported to have opened a book and found the word "*oeuvre,*" which means "work." Lugné-Poe was interested in allowing the work to stand in its own right. His ideas about art had been influenced by his discussions with the Nabis, especially Denis, whose emphasis on the formal properties of painting opened the way for the consideration of art as something in which the literary or descriptive content co-existed with other expressive aspects.

Lugné-Poe, who had already introduced his friends to the theater through the parts he rehearsed in their studio, and through his efforts to sell their paintings to people associated with the theatrical world, involved them in the productions of the Théâtre de l'OEuvre in a number of ways. His friends were called upon to do sets and programs. They were present at rehearsals (cat. no. 109) and were consulted on matters pertaining to production. Vuillard's lithograph gives a sense of the informal way in which the artists were involved.

Whether it was because of the casualness of their participation or the symbolist drama's de-emphasis on personal expression, we have little evidence on what the sets looked like. None remains. The same flats were used over and over, so one set of scenery was painted on top of another. No photographs seem to have been taken of the sets. More

UNE RÉPÉTITION A "L'ŒUVRE"

Lithographie d'EDOUARD VUILLARD

Cat. No. 109

puzzling is the absence of any drawings or maquettes which can be connected with the scenery. Writers on symbolist drama and the meager reports of critics can give us an idea of what the decors looked like and of the ideas which influenced these artists.

Writers on the staging of plays discussed the existence of the actor as an encumbrance and tried to reduce the effects of his presence. (Maeterlinck had proposed that his plays be put on by marionettes.) Gestures were rare, slow and majestic, and actors often spoke in a rhythmic, chanting way. The actors sometimes appeared like statues rather than men.[26]

Writers felt that since the staging submitted to the intentions of the poet, the decorator should not have pretensions. An early symbolist staging of the *Song of Songs* (1891) was held up as a warning; when there was a complicated set where each line and color had significance, it could distract the public. The decor and costumes should be as vague and imprecise as possible. No local color, nothing descriptive or picturesque was encouraged, but rather an accord of nuances and a design in harmony with the poem was called for.[27] In 1891 Pierre Quillard (who sometimes wrote for the *Revue Blanche*) wrote an article on "the utter uselessness of the exact *mise en scene*" in which he discussed the ideal setting.

> Words create a decor like other things . . . The decor should be a simple ornamental fiction which completes the illusion through analogies of colors and lines with the drama. Most often it is sufficient to have a backdrop and several moveable draperies. . . . The spectator . . . abandons himself entirely to the will of the poet and sees, according to his soul, terrible or charming figures and landscapes of illusion where no one besides him will penetrate: the theatre will be what it ought to be, a pretext for dreams.[28]

Accounts of productions at the Théâtre de l'OEuvre report that Lugné-Poe, besides lowering the house lights, which was unusual at the time, also dimmed the lights on stage. Contemporaries reported that the actors sometimes appeared like shadows. This gave the drama a more stylized, less specific quality and allowed the mysterious atmosphere which interested the producer to emerge. In the half light it was difficult to see the actors clearly, and any set which had obeyed the detailed instructions of Ibsen, Hauptmann or

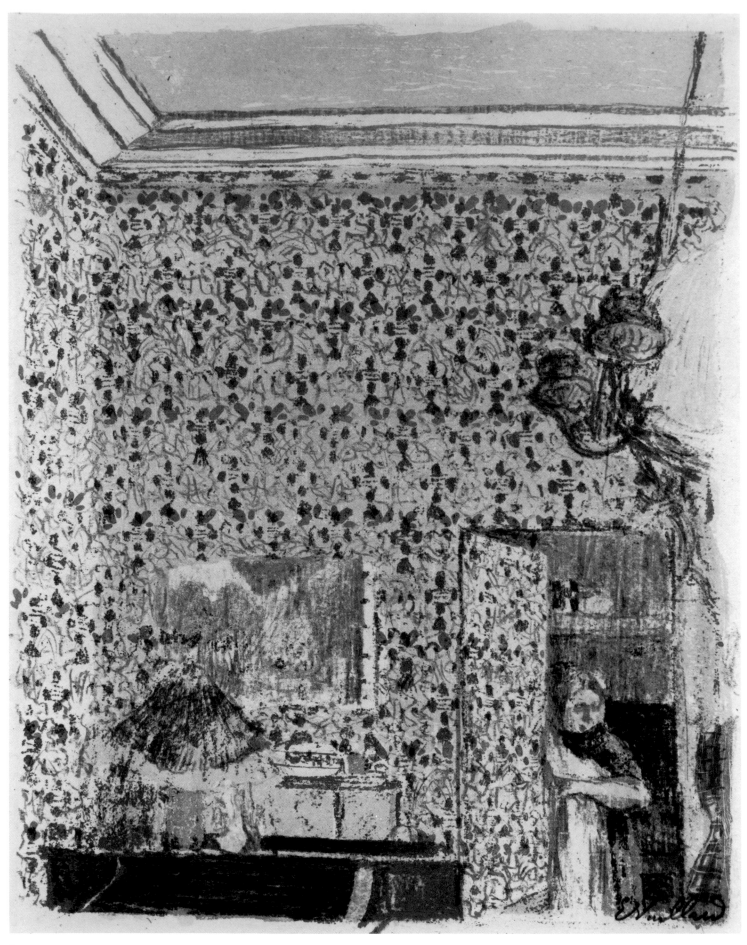

Cat. No. 107

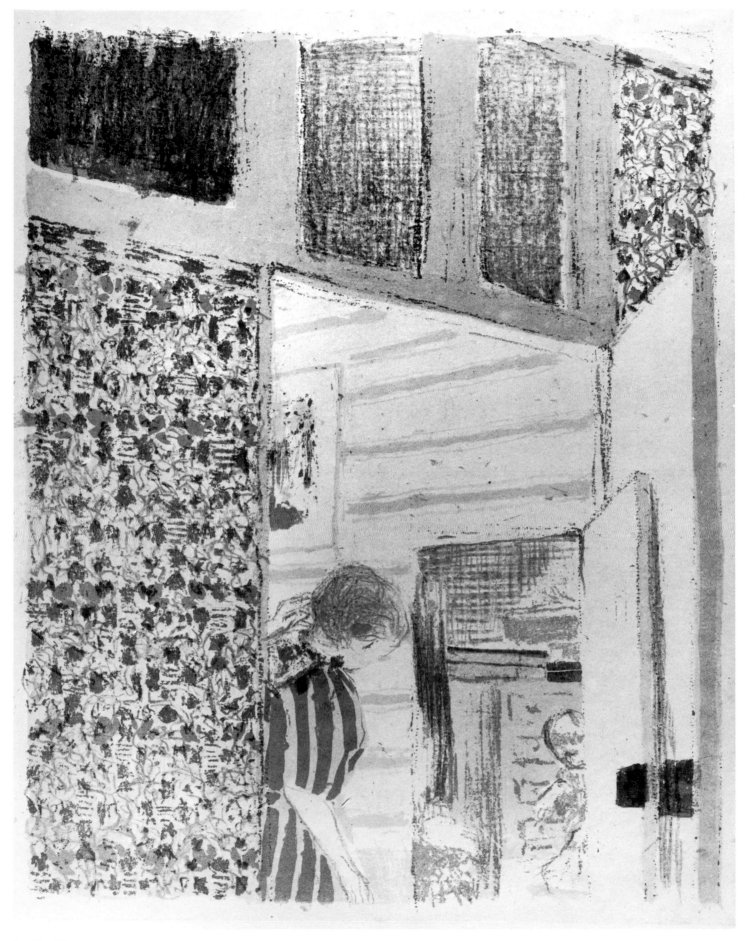

Cat. No. 108

other playwrights, would have been unintelligible. The artists were forced to work with broad, general effects. They were undoubtedly familiar with notions about lack of specificity and suggestion from their contacts with Mallarmé and his circle. In doing the sets they were faced with the problem of adjusting their own styles both to the mode of theatrical presentation and to the practical demands of producing large scale paintings for specific plays within a limited time.

Descriptions of the plays by critics and contemporaries give few details, but can give some indications of the kind of mood the artists succeeded in creating. *Fiérbas,* a play put on in 1891 at the Théâtre d'Art, had a decor by Ibels and Bonnard "in an orange tonality," while that of Ibels and Vuillard for *Berthe aux grands pieds,* on the same program, was in a "violet tonality with violet rocks and golden rain." While these sound indefinite, some sets had figures; the one for an episode from the *Chanson de Roland* on the same program by Ibels and Sérusier, two other Nabis, was green "with the accompaniment of golden warriors executed in an adorable awkward manner which has at once all the character and all the charm of the symbolists."[29] Alfred Jarry wrote of the effect in *Ames Solitaires,* a play by Hauptmann put on by the Théâtre de l'OEuvre in 1893 (after struggles with the police, who claimed it was subversive). He mentioned the "half-mourning of the green lamp on the red tables where Vuillard lighted the vegetative life which made the hands of Kaethe so pale."[30] An interest in effects of lamplight and contrasting colors in an evocative half-light is evident in some of Vuillard's lithographs from the mid-1890s. For all the shadowiness of Lugné-Poe's presentations, color seems to have played a role, and we may speculate that the sets had some of that sense of pattern which is so important in Vuillard's paintings and lithographs of interiors at this time (cat. nos. 106–108). The idea of the suppression of the personality of the actor accords with the way in which figures are presented in Vuillard's, and sometimes Bonnard's, interiors. The individuals, even if identifiable from titles or circumstances, are not presented as individuals, but become participants in some event, or simply elements in an interior. Often the mood which emerges from the colors and patterns is more important than the actions, like playing checkers, which the figures perform. In these pictures, unlike symbolist drama, however, the word plays no role at all; these works have no literary overtones.

In doing programs, the artists dealt more specifically with aspects of the plays. In some cases they showed specific moments in the play. Toulouse-Lautrec showed *Revue Blanche* editor Fénéon delivering the prologue to the *Chariot de terre cuite* and making the single gesture which Signac described as being like a pistol shot (cat. no. 32)[31]. Vuillard and Bonnard more often chose to represent scenes which gave some sense of the character of the play, but were not necessarily events that happened on stage.

Bonnard was less in sympathy with symbolist ideas of evocation than was Vuillard. In his program for *La Derniere Croisade and l'Errante* (cat. no. 11) he showed a nearly nude couple which highlighted the erotic content implicit in both plays, while a group of people conversing suggested the comedy of manners in the *Last Crusade,* a play about a Jewish mistress who converts to Christianity. The symbolic and social overtones of *The Wanderer,* in which a woman, after being given refuge by a despairing man, is inspired to take over his social battles, did not interest Bonnard.

Vuillard, on the other hand, was more evocative in his programs. For the first part of *Beyond Human Strength* (cat. no. 97) he shows a dark mass of people huddled together with lighting on the cross on the wall above them and on the pastors below. The drama, by the Scandanavian playwright Bjornson, dealt with doubts, tests of faith and the issue of miracles. Vuillard gives a sense of mystery which may or may not be supernatural. The advertisement for the *Revue Blanche,* which would have been on the back of the folded program, contrasts markedly in tone. The program for the second part of *Beyond Human Strength* (cat. no. 105) gives a sense of the less spiritual, more socially oriented nature of the play. It deals with the attempts of the daughter of the pastor and his wife who died at the end of the first part, to achieve social justice and to support striking workers. Vuillard suggests the brooding, threatening atmosphere, as well as the milieu in which the action takes place. It is possible that an outdoor set might have looked something like this, just as the patterned wall in the program for *Rosmersholm* and the placement of windows in it and *Les Soutiens de la société* (cat. nos. 94, 104) coupled with the rather sparse furniture, give some idea of what the productions may have looked like, without, in all probability, showing them.

After about three or four years the role of artists in the Théâtre de l'OEuvre diminished. Lugné-Poe no longer

32. Henri de Toulouse-Lautrec (1864–1901)
Program for "Chariot de Terre Cuite," 1894
lithograph
Delteil 77, $^{ii}/_{ii}$
17¼ x 11 in. (440 x 280mm)
The Atlas Foundation

104. Edouard Vuillard (1868–1940)
Program for "The Pillars of Society," 1896
lithograph
Roger-Marx 24, $^{iii}/_{iii}$
15 x 22¼ in. (381 x 565mm)
The Atlas Foundation

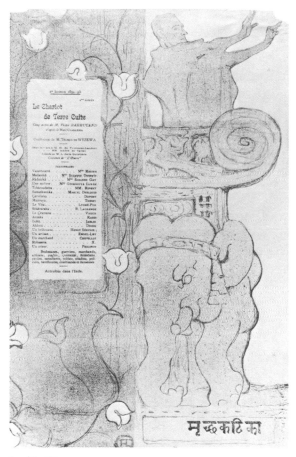

Cat. No. 32

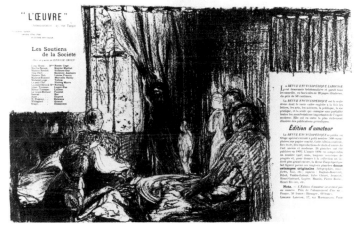

Cat. No. 104

went to the trouble or expense of having a new set painted for each play. A review from 1897 complained that he was using the same backdrop for different rooms in a play by Ibsen, and other reports make it clear that he was working with a bare minimum of props.[32]

Although they were involved in it for only a short time, participation in the theater was important for both the form and content of the work of artists connected with the *Revue Blanche*. It engaged them in making alternatives to easel paintings which were decorative, large-scale works of art and which had to be looked at in a context. The Nabi Dom Verkade wrote in his autobiographical work:

> Toward the beginning of 1890, a war cry went up from one studio to another: No more easel paintings! Painting would not usurp the liberty that isolates it from the other arts. The work of the painter belongs where the architect considers his as finished. The wall should remain surface, should not be pierced for the representation of infinite horizons. There are not paintings, there are only decorations.[33]

Vuillard, Bonnard and Toulouse-Lautrec all executed large-scale works for specific locations. For Vuillard especially, the experience of painting the large stage sets, with the matte non-reflective medium, provided a prototype for work on large paintings which were designed to harmonize with the total interiors in which they were placed.[34]

In addition, these artists were affected by the notion of decoration, which did not have a pejorative sense in the 1890s, but referred to a sensitivity to the interrelating of forms two-dimensionally.

There was some debate at the time about whether an easel painting could be a decoration, or whether the term should apply only to works made for a specific location.[35] In either case artists to whose work the term was applied accepted the flatness of the picture surface and found the arrangement of shapes a more compelling basis for their pictures than a naturalistic recording of something in nature. The way in which one curving form echoes another in Toulouse-Lautrec's poster of *Jane Avril* (cat. no. 26), the way in which the objects and people and letters have been modified in the interest of the curvilinear rhythms (which also suggest the music and the dance movements), and the way in which the space is compressed are all characteristic of decorative art. Similarly, the rhyming of shapes in Bonnard's

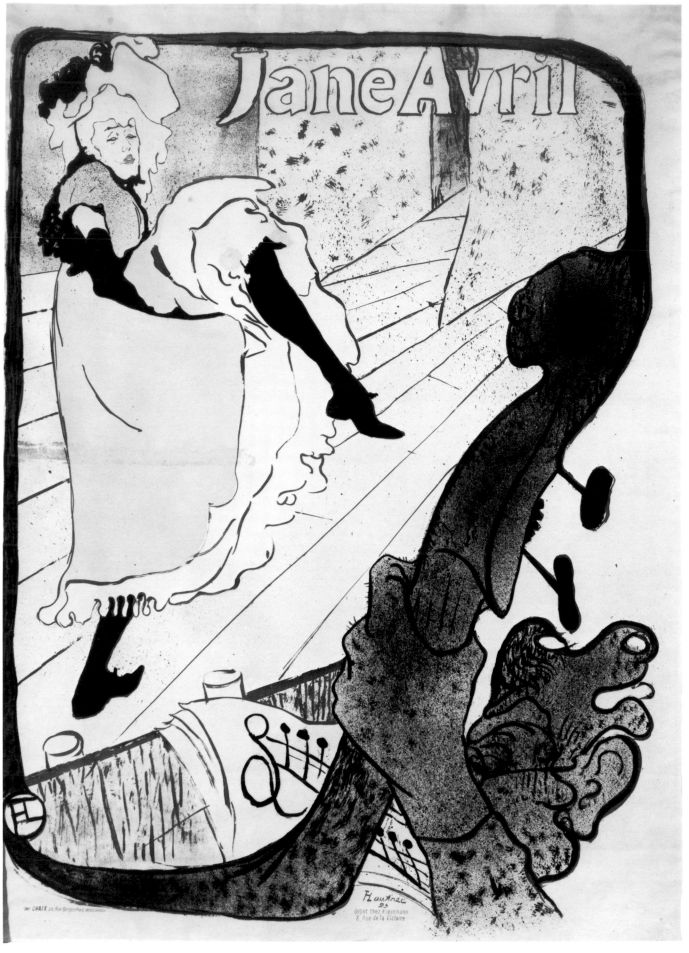

Cat. No. 26

Woman with a Dog (cat. no. 8) and Vuillard's *Portrait of Lugné-Poe* (cat. no. 74) shows a sensitivity to the picture as an arrangement of shapes and colors on a flat surface. An interest in flat, curvilinear forms, areas of color in unusual hues, asymmetrical, rhythmical compositions and a lack of detail linked works by Bonnard, Toulouse-Lautrec, Vallotton and Vuillard with those of Gauguin and his followers, who had been an important influence on them, and with those done in the 1890s by artists of the older generation, like Monet and Pissarro.

Tied as it was to wall painting, stage sets and objects like screens (cat. no. 1), the notion of decoration connected with another aspect of the sensibility of the time, an appreciation of the effect of an ensemble. Vuillard's decorations were praised for the way they connected with everything else in the room.[36] Monet's series, shown in the early 1890s, were praised for their unity.[37] Critics responded to the totality of works in an exhibition.

Thadée Natanson, evoking the effect of a show of Japanese prints in 1893, links the experience of one art form to other sensations.

> About a hundred prints, attached to the walls, envelop the delighted visitor at first with a sweet grace, so delicate and almost enervating, that he hesitates to consider any single one and prefers to abandon his eyes to the caressing harmony of the lovely tenderness of faded tones; golds, ochres, pinks, greens, oranges, grays and reds, where only now and then an intensity of black asserts itself. The tints efface themselves and merge in an atmosphere, with only the flash of an ornament, a coiffure, a dress or some sumptuous object. It is the charm of lovely music of a lullaby-like simplicity which the work of the painter of grace and elegance, Utamaro, evokes.[38]

The idea that works of art have an effect apart from their particular form and content is akin to symbolist ideas of suggestion and, along with the metaphor of music, to which it is linked, shows a movement toward abstraction.

It was perhaps the wish for synthesis, the unity of experience and the melding of the arts which made it possible for writers and artists in the 1890s to communicate fruitfully with one another and to appreciate each other's works. The *Revue Blanche,* with its coverage of so many fields, and its interweaving of aesthetics, personalities and politics, implied that some kind of synthesis was possible.

Throughout its existence the *Revue Blanche* published articles on politics. In 1891 an article entitled "An-archie" stated that although the review was literary, it was above all a field for the development of young personalities, and social questions could not fail to be of interest.[39] Its outlook was more historical than journalistic, although it was distinctly left-wing in the issues it covered: Russian political figures like Bakunin, described as the father of Nihilism, and Herzen; articles on persecutions and intellectual movements in Russia and on socialism in England and elsewhere.

Only with the Dreyfus affair did it become actively involved in the politics of the day, especially in 1898 and 1899.

The circumstances of the affair, in which the case of Dreyfus became the rallying point for proponents of different values, recall Watergate in our own day. In 1894 Alfred Dreyfus, an obscure Jewish staff captain in the intelligence section of the army, was arrested and later convicted and sent to a penal colony. The evidence upon which he was convicted was circumstantial and gradually doubts about his guilt led to demands for his acquittal. A fellow officer, Esterhazy, was tried on the charge of forging the document which had incriminated Dreyfus, but was acquitted. In 1898 Emile Zola, the novelist, wrote a sensational letter, published in the newspaper *L'Aurore* with the headline "J'accuse" in which he accused ministers and army officers of concealing the truth. Finally Esterhazy was arrested for forgery. Dreyfus was retried, but under the French system of justice, which does not presume the innocence of the accused, he was found guilty again, which caused further outcry. He was finally pardoned in 1906.

The case became a focus for much larger issues, especially the power of institutions, the church, and the establishment in general. Those who claimed Dreyfus's innocence considered that they stood for justice and the individual; they pitted themselves against the army and Catholic officers, devoted to order, hierarchy and obedience, who were perpetuating the ideas of the old regime. Anti-semites saw the Dreyfus case as a conspiracy, backed by Protestants, and the Catholic clergy took up this position. Just as the actual facts of the case remained confused (Dreyfus was not guilty, but someone was), the outcome was also unclear. It did not become an election issue in 1898, although it stirred extreme passions among the groups most involved.

65. **Félix Vallotton (1865–1925)**
At Age Twenty (A Vignt Ans), 1894
woodcut
Vallotton and Goerg 134
9⅝₁₆ x 13 in. (236 x 330mm)
The University of Michigan Museum of Art

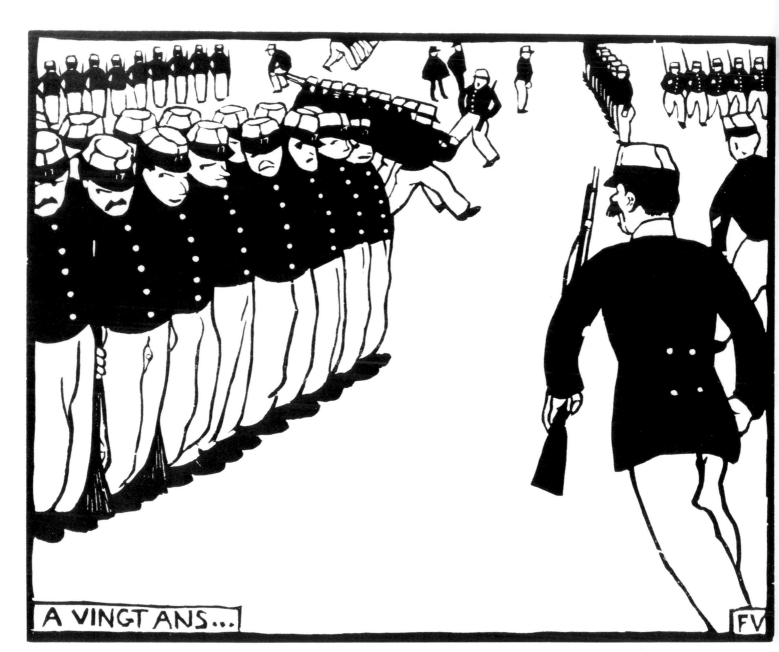

Cat. No. 65

One of the most important outcomes of the affair, according to Zeldin, and one which was relevant for the group surrounding the *Revue Blanche,* was the sense that it gave to intellectuals of their power and of their mission.[40] Ironically, this sense of direction was one of the factors in the demise of the *Revue Blanche.* Once the passions roused by the affair had died down, the *Revue Blanche* lost its sense of purpose, but it was not able to resume its earlier inclusiveness in the same way. Many of the "young personalities" had developed and had found more congenial outlets for their work.[41]

It was on the level of personality, rather than ideology, that the Dreyfus affair affected the artists of the *Revue Blanche.* The affair was notorious for destroying social occasions, straining family relations and breaking up friendships. Degas, an anti-Dreyfusard, cut off his acquaintance with many of his old friends. The *Revue Blanche* circle, which included the Natansons, of Jewish background, and Jewish writers, as well as anarchists, was identified as a pro-Dreyfus one. The *Revue Blanche* artists were Dreyfusards, but the murky affair lent itself better to political cartoons than to the kind of art they practiced. Nevertheless, Vallotton's prints, especially ones like *A Vingt ans* (cat. no. 65) indicated the anti-militaristic sentiments, already alive in 1894, which fed the affair.

As the *Revue Blanche* matured, its treatment of artists focused less on exhibitions and on the experience of the works, and more on history. It published Gauguin's memoir, "Noa Noa" (in a version in collaboration with Charles Morice) in 1897. The same year, Antonin Proust's "Edouard Manet—Souvenirs" came out in many installments, and the next year Paul Signac's "From Delacroix to Neo-Impressionism" was published serially. Without ceasing to cover current events, the *Revue Blanche* seemed to be providing its artists with their own history.

The *Revue Blanche,* in its attempt to encompass so much, was characteristic of the 1890s. It spanned a period of complex activity in which many aspects of the nineteenth century were coming to a close, while attitudes which now seem basic to the twentieth century were emerging. It provided a forum for new ideas and fostered artists and writers who were going in new directions. The time of intense collaboration, of dreams shared between writers, artists and political activists, could not last forever. As the twentieth century began, the *Revue Blanche* ended.

Grace Seiberling

FOOTNOTES

1. Roger Shattuck, *The Banquet Years: The Arts in France 1885–1918, Alfred Jarry, Henri Rousseau, Erik Satie, Guillaume Apollinaire* (Garden City, N.Y.: Doubleday, 1961).

2. Leader, *Revue Blanche*, n.s. 1, (1890): 1.

3. For information on the Natansons and their circle see Arthur Gold and Robert Fizdale, *Misia: The Life of Misia Sert* (New York: Knopf, 1980).

4. Thadée Natanson, "Les Expositions: La Rose + Croix," *Revue Blanche*, n.s. 10 (1896): 336.

5. Henri Mondor, *Vie de Mallarme* (Paris: Gallimard, 1941), p. 624 and passim; Ed. Bonniot, "Mardi soir, rue de Rome," *Les Marges* 57 (1936): 17–18 and passim.

6. J. E. Blanche, "Les Objets d'art: 1. Au Salon du Champs-de-Mars," *Revue Blanche*, n.s. 8 (1895): 463.

7. Raymonde Moulin, "Les Expositions des beaux-arts en province 1885–7," (Thesis, Sorbonne, 1967), p. 10.

8. Thadée Natanson, "Salon des Indépendants," *Revue Blanche*, n.s. 10 (1895): 378–79.

9. Emile Verhaeren, "Les Musées," *Revue Blanche*, n.s. 9 (1895): 65–66.

10. Thadée Natanson, "Expositions: I M. Claude Monet, II Estampes et dessins de MM. H. de Toulouse-Lautrec, F. Vallotton et P. Bonnard," *Revue Blanche*, n.s. 8 (1895): 521.

11. Thadée Natanson, "Paul Cézanne," *Revue Blanche*, n.s. 9 (1895): 497.

12. Thadée Natanson, "'Art nouveau,'" *Revue Blanche*, n.s. 10 (1896): 115–17.

13. Edmond Cousturier, "Galeries S. Bing: Le Mobelier," *Revue Blanche*, n.s. 10 (1896): 94.

14. A. B. Jackson, *La Revue Blanche (1889–1903) Origine, influence, bibliographie* (Paris: Minard, 1960) gives a list of prints published.

15. For color prints see Phillip D. Cate and Sinclair H. Hitchings, *The Color Revolution: Color Lithography in France 1880–1900* (Santa Barbara and Salt Lake City: Peregrine Smith, 1978).

16. For Vollard's activities in this sphere see Una E. Johnson, *Ambrose Vollard Editeur: Prints, Books, Bronzes* (New York: Museum of Modern Art, 1977).

17. August Strindberg, "L'Inferiorité de la femme, et comme corrollaire de la justification de sa situation subordonnée selon des données dernières de la science," *Revue Blanche*, n.s. 8 (1895): 1–20.

18. Nancy J. Troy, "Interiorization in French Art and Design in the 1890s," College Art Association meetings, 1981.

19. Thadée Natanson, "Pierre Bonnard," *Revue Blanche*, n.s. 10 (1896): 72.

20. "Chronique de la littérature," *Revue Blanche*, n.s. 1 (1890): 142–4.

21. "Les Revues," *Revue Blanche*, n.s. 5 (1893): 177–78.

22. Pierre Louÿs, "Les Marionnettes," *Revue Blanche*, n.s. 5 (1894): 573.

23. Gold and Fizdale, *Misia*, pp. 43–45.

24. Gertrude R. Jasper, *Adventure in the Theatre: Lugné-Poe and the Théâtre de l'Oeuvre to 1899* (New Brunswick: Rutgers University Press, 1947) pp. 172–75. For the history of theater at the time see John Henderson, *The First Avant-Garde 1887–1894: Sources of the Modern French Theatre* (London: Harrap, 1971) and Jacques Robichez, *Le Symbolisme au théâtre: Lugné-Poe et les débuts de l'OEuvre* (Paris: L'Arche, 1957).

25. Lugné-Poe's memories of the time were published in *Parade de la baraque: souvenirs de Lugné-Poe* (Paris: J. Théry, n.d.).

26. Robichez, *Symbolisme au théâtre*, p. 187 cites P. Valin, "A Propos du Fils des Etoiles," *L'Ermitage* 4 (1892) and Ch. Morice, "A Propos du Théâtre d'art," *Mercure de France* (May 1895) who said that the effacement of the actor was the principal merit of the Théâtre d'Art and that the Théâtre Libre had suffered from having too many stars.

27. F. Coulon, "De l'action dans la drame symbolique," *La Plume* (11 December 1892); Alphonse Germaine, "De la decoration au théâtre," *Ibid.*, (1 February 1892) quoted Robichez, *Symbolisme au théâtre*, pp. 187–88.

28. P. Quillard, "De l'inutilité absolu de la mise en scéne exact," *Revue d'Art Dramatique* (1 May 1891) quoted Robichez, *Symbolisme au théâtre*, p. 188.

29. "La Mise en scène symboliste," *Le Gaulois* (14 December 1891) quoted Robichez, *Symbolisme au théâtre*, p. 132.

30. Alfred Jarry, "Ames Solitaires," *L'Art littéraire* (January–February 1894) quoted Robichez, *Symbolisme au théâtre*, p. 247.

31. Paul Signac, "Extraits du journal inédit de Paul Signac, I, 1894–1895," ed. John Rewald, *Gazette des Beaux-Arts*, ser. 6, 36 (1949): 115.

32. Robichez, *Symbolisme au théâtre*, p. 248.

33. Don W. Verkade, *Le Tourment de Dieu, étapes d'un moine peintre*, (Paris: 1923): 94.

34. James Dugdale, "Vuillard the decorator, I, First phase: the 1890s," *Apollo*, 81 (February 1965): 96–97 points out that Vuillard used *colle de peaux* for his theater scenery, a medium which was similar to *peinture à colle*, which he used for most of his decorations; it had a flat, non-reflective surface and its colors were not falsified by artificial light.

35. For instance, see Pissarro's letter of 1892 to his son in which he expresses his agreement with Degas that a decoration should be part of an ensemble. Camille Pissarro, *Lettres à son fils Lucien*, ed. Lucien Pissarro and John Rewald (Paris: Michel, 1950), p. 194.

36. Paul Signac, "Extraits du journal inédit de Paul Signac, III, 1898-1899," ed John Rewald, *Gazette des Beaux-Arts*, ser. 6, 42 (1953): 35.

37. Pissarro, *Lettres*, p. 382; "Exposition Claude Monet: Après les meules—le principe des variations—sur un thème unique," *L'Eclair*, 1 March 1892. This critic wrote, "When you have seen them all united, you can no longer conceive of the possibility of separating them."

38. Thadée Natanson, "Expositions: Estampes de Outamaro et de Hiroshighé," *Revue Blanche*, n.s. 4 (1893): 139.

39. Ludovic Malquin, "L'An-archie," *Revue Blanche*, n.s. 1 (1891): 97.

40. Theodore Zeldin, *France 1848–1945, 1, Ambition, Love and Politics* (Oxford: Clarendon Press, 1973): 681.

41. Jackson, *Revue Blanche*, pp. 108 ff.

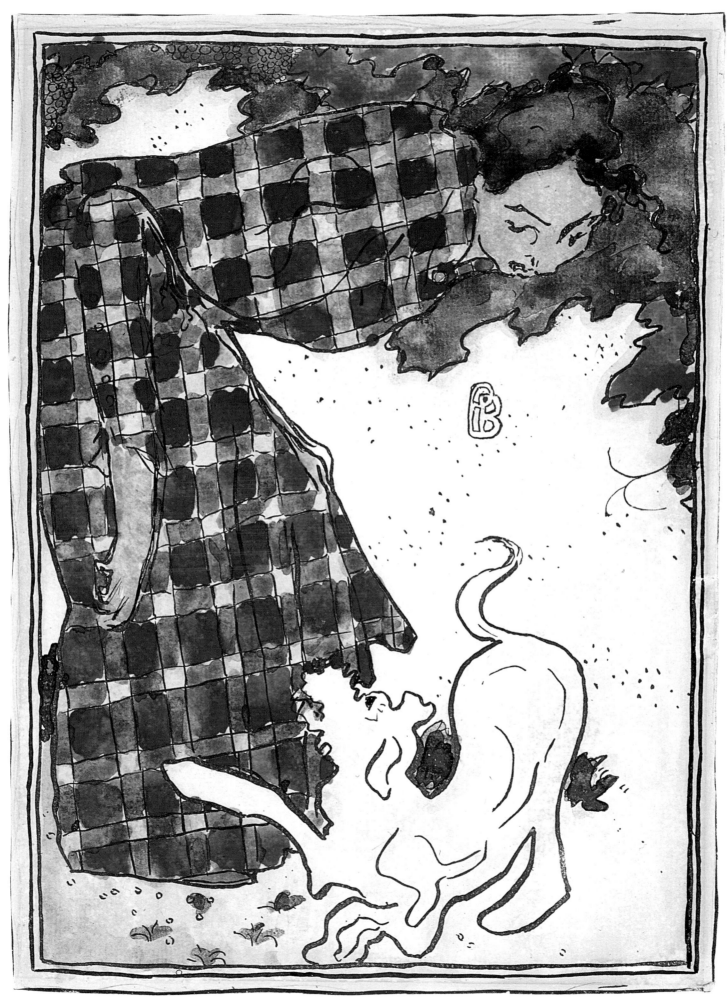

Cat. No. 8

6. **Pierre Bonnard (1867–1947)**
Luncheon Table, c. 1900
oil on board
19½ x 25¾ in. (495 x 654mm)
The Baltimore Museum of Art
Baltimore, Md.
Frederic W. Cone Bequest (1950.189)

18. **Henri de Toulouse-Lautrec (1864–1901)**
Repos pendant le bal masque, c. 1899
oil and gouache on cardboard
22½ x 15¹³⁄₁₆ in. (572 x 351mm)
The Denver Art Museum
The T. Edward and Tullah Hanley Memorial Gift

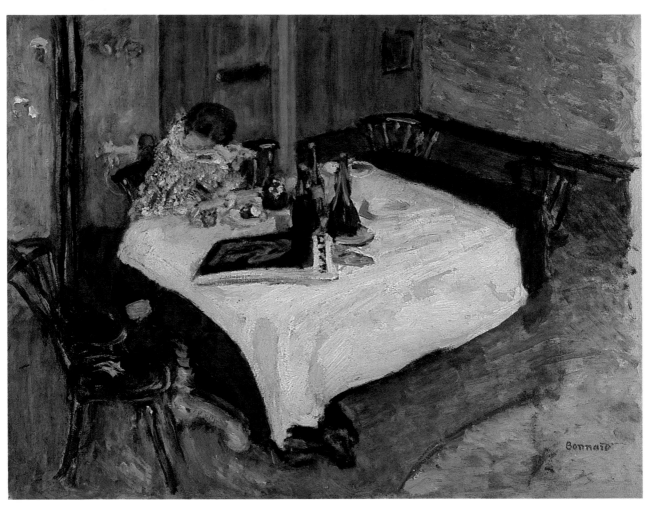

Cat. No. 6

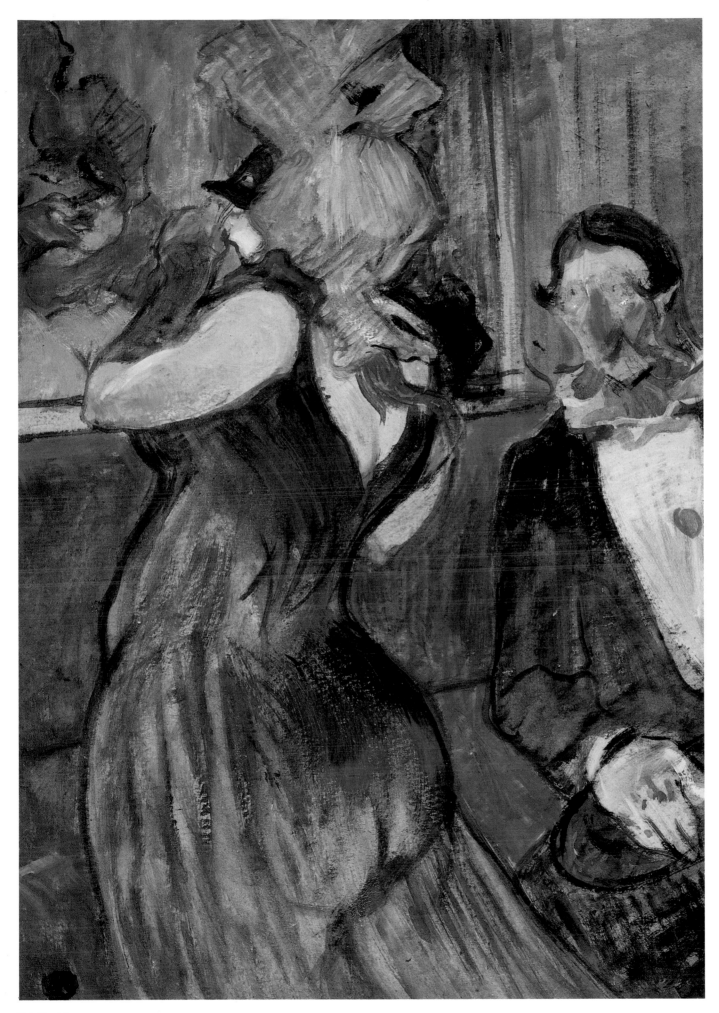

Cat. No. 18

49. **Félix Vallotton (1865–1925)**
The Lie, 1897
oil on composition board
9¼ x 13 in. (235 x 330mm)
The Baltimore Museum of Art
The Cone Collection, formed by Dr. Claribel Cone
and Miss Etta Cone of Baltimore, Maryland (BMA 1950.189)

50. **Félix Vallotton (1865–1925)**
Portrait of Thadée Natanson, 1897
oil on composition board
26⅜ x 18⅞ in. (665 x 480mm)
Lent by Petit Palais Musée, Geneva, Switzerland

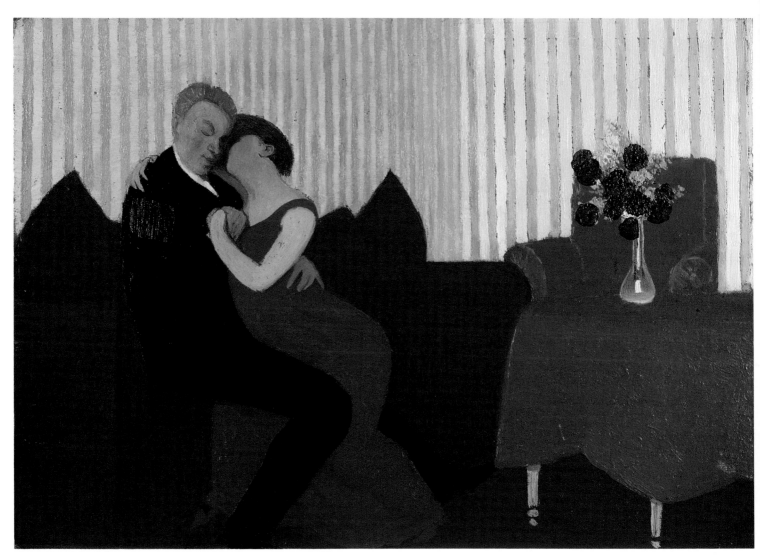

Cat. No. 49

Cat. No. 50

74. **Edouard Vuillard (1868–1940)**
Portrait of Lugné-Poë, 1891
oil on panel
9½ x 10½ in. (240 x 265mm)
Memorial Art Gallery
Rochester, N.Y.
Gift of Mr. Fletcher Steele

78. **Edouard Vuillard (1868–1940)**
Misia and Thadée Natanson, c. 1897
oil on paper mounted on canvas
36½ x 29¼ in. (927 x 743mm)
The Museum of Modern Art, New York
Gift of Nate B. and Frances Spingold, 1957
(270.57)

80. **Edouard Vuillard (1868–1940)**
Portrait of Félix Vallotton, 1900(?)
oil on cardboard
11⁷⁄₁₆ x 7⅞ in. (290 x 200mm)
Lent by Galerie Paul Vallotton, Lausanne, Switzerland

Cat. No. 80

Cat. No. 74

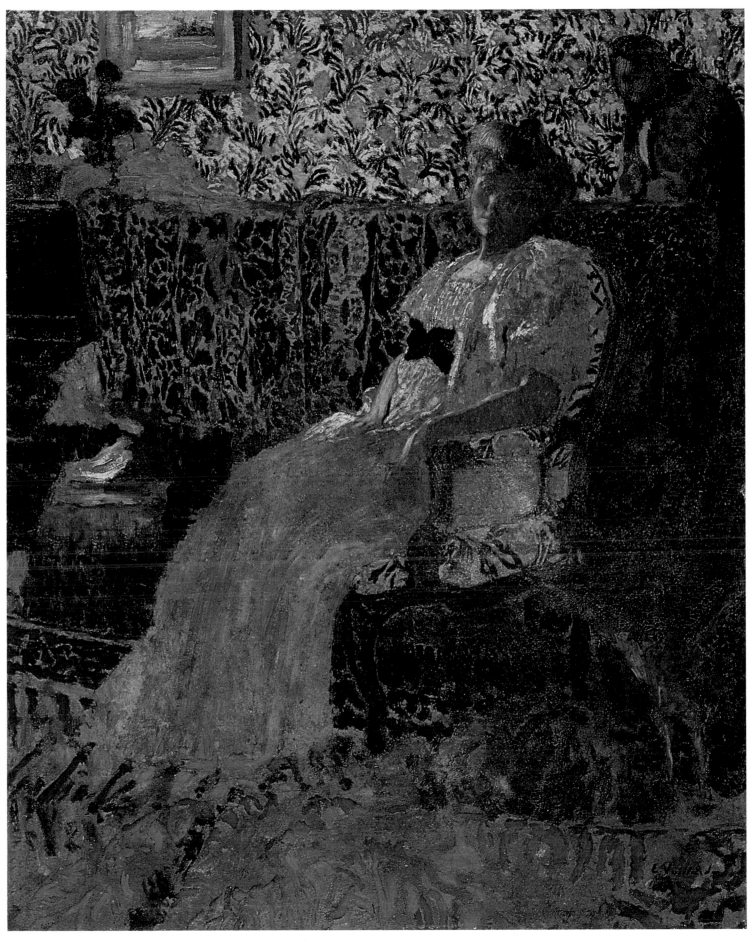

Cat. No. 78

81. **Edouard Vuillard (1868–1940)**
At the Revue Blanche (*Portrait of Félix Fénéon*), 1901
oil on board
18¼ x 22⅝ in. (464 x 575mm)
The Solomon R. Guggenheim Museum, New York

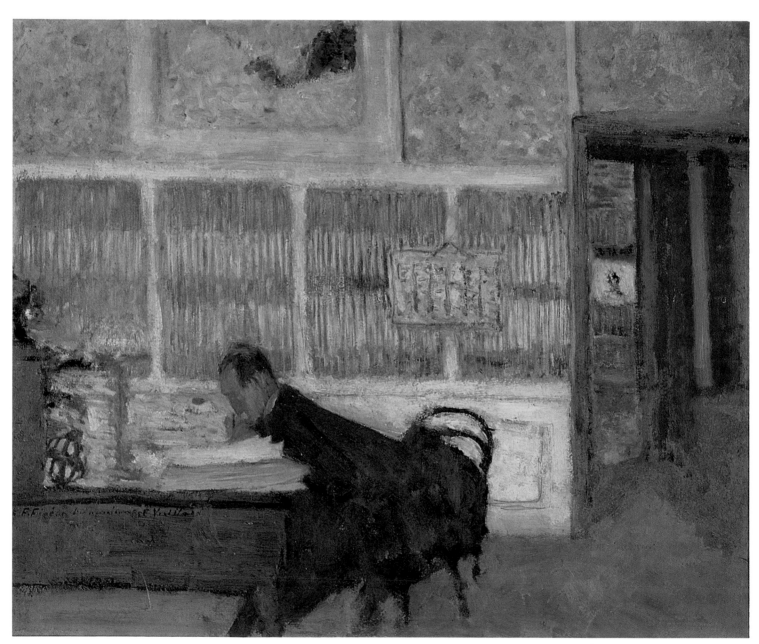

Cat. No. 81

CATALOGUE

1. **Pierre Bonnard (1867–1947)**
Boy with a Dog, c. 1892
tempera on linen
62½ x 19½ in. (1587 x 459mm)
Museum of Fine Arts
Springfield, Mass.
The Robert J. Freedman Memorial Collection (73.27)

"Our generation has always sought to connect art with life," said
Bonnard, adding apropos his early work, "at that time I myself had
the idea of a popular production and of utilitarian application:
prints, furniture, fans, screens, etc." (Antoine Terrasse, *Pierre
Bonnard* [Paris: Editions Gallimard, 1967] p. 23).

 This is one of four decorative panels which were
described, when exhibited at the Museum of Modern Art in 1948,
as segments of a folding screen and dated c. 1891-92 (Rewald,
Bonnard, pp. 64, 139). Jean and Henry Dauberville, in their 1965
catalogue raisonné of Bonnard's early paintings, suggest a date of
around 1899. Since the four panels did not form an integrated
composition it seems possible that they were not originally an
ensemble and might even have been painted at different periods.
On stylistic grounds the earlier dating seems more convincing for
this panel. Like a folding screen dated 1894 (D.60) it features in
the foreground a child with a hoop and a dog and in the back-
ground a horse-drawn cab with its dozing driver. The child's dress,
in which the plaid pattern does not conform to the contours of the
figure but is represented as a flat panel, is also reminiscent of
earlier works like *The Croquet Party* (D.38) of 1892. It calls to mind
as well the conventions of Japanese color woodcuts which Bonnard
admired to such a degree that he was nicknamed by his friends of
the Nabi brotherhood "The Ultra-Japanese Nabi."

2. **Pierre Bonnard (1867–1947)**
La Revue Blanche, 1894
gouache on paper
31¼ x 23½ in. (794 x 597mm)
New Orleans Museum of Art
New Orleans, La.
Gift of Mr. and Mrs. Frederick Stafford (76.421)

This study for Bonnard's famous *Revue Blanche* poster of 1894
reveals the care with which Bonnard worked out his seemingly
casual compositions. Even such minor details as the comma-like
white shape at the left between the woman's arm and her body is
repeated almost exactly in the poster. A number of other
preliminary drawings exist.

Cat. No. 1

Cat. No. 3

Cat. No. 5

3. **Pierre Bonnard (1867–1947)**
Rooftops, c. 1897
oil on cardboard
13½ x 15 in. (343 x 369mm)
Smith College Museum of Art
Northampton, Mass.
Gift of the Adele R. Levy Fund, Inc. 1962:23

A view of rooftops on the rue des Abbesses near the Montmartre studio into which Bonnard moved in 1893. The painting is signed by the artist and inscribed "à Paul Bonis."

4. **Pierre Bonnard (1867–1947)**
The Artist's Sister and Her Children, 1898
oil on cardboard mounted on wood
12 x 10 in. (305 x 254mm)
National Gallery of Art, Washington, D.C.
Ailsa Mellon Bruce Bequest

In 1890 Bonnard's sister, Andrée, married the composer Claude Terrasse. She is depicted here with their three children and an unidentified standing woman, perhaps a nurse.

5. **Pierre Bonnard (1867–1947)**
Two People on a Couch
oil on canvas
9 x 13¼ in. (229 x 337mm)
Museum of Fine Arts
Springfield, Mass.
The Robert J. Freedman Memorial Collection (73.26)

The balding man may be Bonnard's friend the painter Edouard Vuillard. If so, the woman could well be Misia Natanson.

6. **Pierre Bonnard (1867–1947)**
Luncheon Table, c. 1900
oil on board
19½ x 25¾ in. (495 x 654mm)
The Baltimore Museum of Art
Baltimore, Md.
Frederic W. Cone Bequest (1950.189)

7. **Pierre Bonnard (1867–1947)**
Design for Théâtre Libre Program, c. 1891
watercolor and ink
12⅜ x 7⅞ in. (317 x 202mm)
The Atlas Foundation

In the early 1890's Bonnard, Vuillard and the painter Maurice Denis shared a small studio with the young actor Aurélian Lugné-Poë who at that time was a member of the Théâtre Libre company. No doubt encouraged by Lugné-Poë, both Bonnard and Vuillard designed programs for the Théâtre Libre that seem never to have been used.

8. Pierre Bonnard (1867–1947)
Woman with a Dog, c. 1892
watercolor, pen and pencil
10⅛ x 7¼ in. (257 x 184mm)
Museum of Fine Arts
Springfield, Mass.
Purchased in memory of Frederic Bill (47.DO2)

Bonnard's use of line in this delightful watercolor brings to mind critic Gustave Geffroy's observation concerning the early work of both Bonnard and Vuillard: "They can manipulate every possible complication of line—symmetrical, asymmetrical, knotted and unknotted—in a delightfully convoluted and decorative way." (*La Vie Artistique,* Paris, 1893.)

9. Pierre Bonnard (1867–1947)
Reine de Joie, 1892
color lithographic book cover
Bouvet 3
7½ x 10¼ in. (191 x 260mm)
Lent by Bret and Mary Lou Waller

Victor Joze was the pen name of a successful Polish-born novelist Victor Dobrski. In *Reine de Joie,* Joze explored the milieu of a Parisian demimondaine. Bonnard's cover design, of course, was intended to wrap around the book so that the left and right halves would not be seen simultaneously. Viewed in this way the design loses some of the spatial ambiguity it exhibits when displayed unfolded, as in this exhibition. Lautrec later executed a poster advertising *Reine de Joie* (cat. no. 22).

10. Pierre Bonnard (1867–1947)
La Revue Blanche, 1894
lithographic poster
Bouvet 30
31⅜ x 24⁵⁄₁₆ in. (797 x 618mm)
The University of Michigan Museum of Art

This is Bonnard's second and last lithographic poster. His first effort in the genre was an advertisement for France-Champagne which appeared on the walls of Paris early in 1891 and is credited with inspiring Toulouse-Lautrec to create the first of his great lithographic posters later that year.
 The model for the female figure may be Maria Boursin, with whom Bonnard became intimate in 1893 and who remained with him until her death in 1942.

> He had met at the end of 1893 a young woman of twenty-four; she had a graceful body, beautiful hair, periwinkle blue eyes and was named Maria Boursin; but she preferred the given name of Marthe and Bonnard gave her his name in 1925 (. . .) It is she whom one sees in many of the first lithographs.
> (Antoine Terrasse, *Pierre Bonnard,* Paris, 1967, p. 52.)

Cat. No. 11

11. Pierre Bonnard (1867–1947)
Program for *"La Dernière Croisade"* and *"L'Errante"*, 1896
lithograph
Bouvet 37
12¾ x 19¾ in. (324 x 502mm)
The Atlas Foundation

La Dernière Croisade by Maxime Gray and *L'Errante* by Pierre Quillard were presented at the Théâtre de l'Oeuvre on April 22, 1896. Bonnard, Vuillard and other artists participated actively in designing sets and costumes for the productions of their friend Lugné-Poë, founder and director of the Théâtre de l'Oeuvre which specialized in Symbolist drama. This is a proof impression of the program before the addition of the text describing the play.

12. Pierre Bonnard (1867–1947)
Obscene Lullaby (Berceuse obscène), 1898
lithographic sheet music cover
Bouvet 47
12¼ x 9⅞ in. (310 x 250mm)
Metropolitan Museum of Art, The Elisha Whittelsey Collection, The Elisha Whittelsey Fund, 1948

This is one of six sheet music covers executed by Bonnard for songs in the *Répertoire des Pantins* composed by his brother-in-law Claude Terrasse with lyrics by the poet Franc-Nohain. The Théâtre des Pantins was a puppet theatre founded by Terrasse, Franc-Nohain and the author and playwright Alfred Jarry. Bonnard and Vuillard decorated the theatre, designed sets and even made puppets.
 As the song's title and Bonnard's illustration suggest, Franc-Nohain's lyrics were often risqué and sometimes bawdy.

Cat. No. 13

Cat. No. 14

13. **Pierre Bonnard (1867–1947)**
La Petite Loge, 1898
lithograph printed in four colors
Bouvet 53
8¼ x 7½ in. (210 x 190mm)
Memorial Art Gallery Anonymous Gift (79.65)

Created as the frontispiece for André Mellerio's book *La litho-graphie en couleurs* for which Bonnard also executed the cover, this print depicting a couple seated in a theatre box, reflects Bonnard's interest in Parisian night life in general and the theatre in particular during the 1890's.
Of Bonnard, Mellerio wrote:

> [He is] a fine painter, and an original draughtsman, [and] is equally gifted from the standpoint of the print. He has an understanding of prints which is at once personal and distinctive. His free fantasy, his obser-vation of life around him, the piquancy of his black and white illustrations, and also the matt effects which he often worked for in his painting have predisposed him to printmaking. And then, again, he has, without being inclined to imitation, a bit of that Japanese love of checkered or floral designs which lend to the effects of the print. (Mellerio, *La lithographie en couleurs,* 1898, reprinted in *The Color Revolution,* P. D. Cate and S. H. Hitchings, translation by M. Needham, 1978, p. 79.)

14. **Pierre Bonnard (1867–1947)**
Le Pont, 1899
color lithograph
Bouvet 66
10 5/8 x 16⅛ in. (270 x 410mm)
The University of Michigan Museum of Art

From the album *Quelques aspects de la vie de Paris* published by the dealer Ambroise Vollard in 1899, this four-color lithograph demonstrates Bonnard's ability to create a striking decorative design from the hustle and bustle of Parisian street life without sacrificing the sense of immediacy and reality.

> M. Bonnard catches instantaneous poses, he pounces upon unconscious gestures, he captures the most fleeting expressions; he is gifted with the ability to select and quickly absorb the pictorial elements in any scene, and in support of this gift he is able to draw on a delicate sense of humor, sometimes ironic, always very French. (Claude Roger-Marx, "Les Independents," *Le Voltaire,* March 28, 1893.)

Cat. No. 19

15. **Pierre Bonnard (1867–1947)**

Coin de rue, 1899
color lithograph
Bouvet 60
10 5/8 x 13¾ in. (270 x 350mm)
Lent by Professors Alice and George Benston,
University of Rochester

The similarity between Bonnard's composition with small figures dotting a street viewed from above and a village scene by the Japanese woodcut master Hiroshige has been noted by Colta Ives. (Colta Feller Ives, *The Great Wave: The Influence of Japanese Woodcuts on French Prints* [New York: The Metropolitan Museum of Art, 1974] p. 61.)

16. **Pierre Bonnard (1867–1947)**

Les Boulevards, 1900
color lithograph
Bouvet 72
11⅞ x 14 in. (302 x 356mm)
The University of Michigan Museum of Art

This four-color lithograph was published in Leipzig as part of an album of twenty-four prints. Works by Vuillard and Maurice Denis also were included.

17. **Henri de Toulouse-Lautrec (1864–1901)**

Babylone d'Allemagne, 1894
peinture à l'essence on board
22⅞ x 15⅜ in. (580 x 390 mm)
The Phillips Family Collection

This is a study for a poster (Delteil 351) advertising the novel *Baby-lone d'Allemagne* by the Polish author Victor Dobrski who wrote under the pen name Victor Joze. The novel, set in contemporary Germany, is a scathing satire of militarism and corruption in German society. Lautrec also designed a poster for *Reine de Joie* by the same author (cat. no. 22) and Bonnard produced a cover design for the book (cat no. 9).

18. **Henri de Toulouse-Lautrec (1864–1901)**

Repos pendant le bal masqué, c. 1899
oil and gouache on cardboard
22½ x 15¹³⁄₁₆ in. (572 x 351mm)
The Denver Art Museum
The T. Edward and Tullah Hanley Memorial Gift

Seated at the right is Dr Tapié de Céleyran, Lautrec's cousin and frequent companion who sometimes accompanied the artist on his visits to the Natansons' summer homes. In this broadly painted caricature Lautrec depicts the red-nosed doctor eyeing a thinly-clad, Rubensian female who adjusts her mask during a pause at one of the masked balls that were so prominent a feature of Parisian night life in the latter part of the nineteenth century.

Masked balls, given every night at the opera during the carnival season, had become "less intimate and less exclusive socially during the later, more democratic years of the Republic." Characteristically, Lautrec transformed the society ball into "a common cabaret scene like those [he] witnessed daily in the night clubs and dance halls of Montmartre." (Theodore Reff, *Manet and Modern Paris,* [Washington, D.C.: National Gallery of Art, 1982] p. 126.)

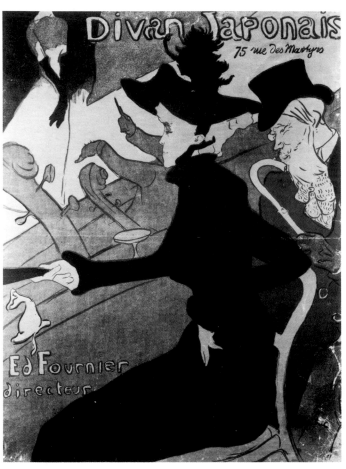

Cat. No. 20

19. Henri de Toulouse-Lautrec (1864–1901)

Le Pére Cotelle, c. 1893
charcoal with red and blue crayons
19¹⁵/₁₆ x 13⅝ in. (507 x 346mm)
The Art Institute of Chicago
The Mr. and Mrs. Carter H. Harrison Collection (1933.880)

This is a study for Lautrec's cover for the first portfolio of *L'Estampe Originale,* which also included prints by Bonnard, Vallotton and Vuillard, among others.

 The subject of this drawing is Pére Cotelle, lithographic printer for the firm of Edward Ancourt where Lautrec's first lithographic posters were produced. Pére Cotelle is depicted turning the "spider wheel," propelling a lithographic stone through the press.

 In the *L'Estampe Originale* cover for which this is a study Lautrec includes in the foreground Jane Avril examining a freshly-pulled impression of a print.

20. Henri de Toulouse-Lautrec (1864–1901)

Divan Japonais, 1892
color lithographic poster
Delteil 341
31¼ x 23⁷/₁₆ in. (795 x 595mm)
Memorial Art Gallery
Rochester, N.Y.
Gift of the Corner Club of Rochester, through
Mrs. Francis E. Cunningham (52.62)

The woman seated in the foreground is the dancer Jane Avril. Her companion is the writer and critic Edouard Dujardin, founder of *La Revue Wageriénne,* director of *La Revue indépendante* and occasional contributor to the *Revue Blanche.* The performer at upper left, identifiable by her long black gloves even though her face is hidden, is the singer Yvette Guilbert. The *Divan Japonais* was a small *café-concert* decorated in pseudo-Japanese style on the rue des Martyrs near the offices of the *Revue Blanche.*

 Jane Avril made her debut as a dancer at the Moulin Rouge in 1889, "after enduring a childhood of deprivation and indignity."

 Something of her past flavored her self-taught style of dance, which was less boisterous than that of such associates as La Goulue. In fact, Jane Avril was most greatly admired for her solo dances. The legendary expressive range of her dancing is perhaps suggested by her reputedly wide literary tastes and the extraordinary circle of artistic friends she kept, including Lautrec. (Stuckey, *Toulouse-Lautrec: Paintings,* p. 181.)

 According to Lugné-Poë Jane Avril was "incomparable" as Anitra in the 1896 Théâtre de l'Oeuvre production of Ibsen's *Peer Gynt.*

21. Henri de Toulouse-Lautrec (1864–1901)

Ambassadeurs: Aristide Bruant, 1892
color lithographic poster
Delteil 343
59 x 39⅜ in. (1500 x 1000mm)
From the collection of Mr. and Mrs. Herbert D. Schimmel

This poster of cabaret performer Aristide Bruant at the *Ambassadeurs* is the mirror image of one for Bruant at the *Eldorado.* Lautrec depicted Bruant in a similar pose but seen from the back in another poster the following year (cat. no. 27). The silhouetted figure leaning against the wall in the background may allude to the subject matter of many of Bruant's songs: the working poor, the destitute and the petty criminals of Paris.

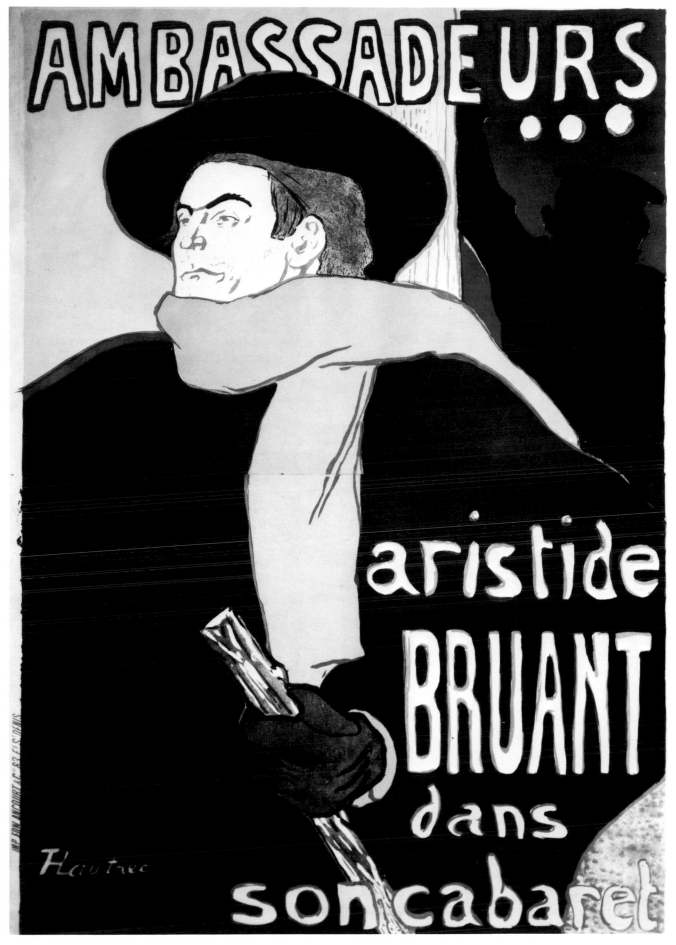

Cat. No. 21

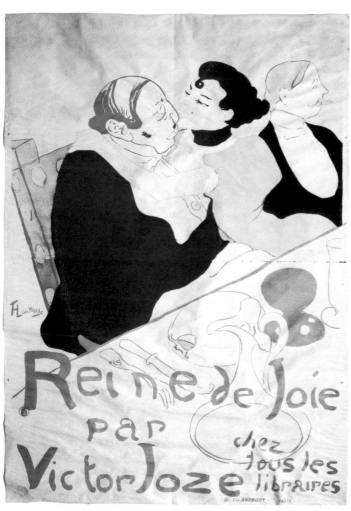

Cat. No. 22

22. Henri de Toulouse-Lautrec (1864–1901)
Reine de Joie, 1892
color lithographic poster
Delteil 342
51%6 x 35¼ in. (1300 x 895mm)
Mr. and Mrs. Herbert D. Schimmel

This poster advertises *Reine de Joie,* a novel by the Polish author Victor Dobrski who wrote under the nom de plume Victor Joze. Bonnard designed the cover for the book (cat. no. 9) which chronicles the life of a Parisian demimondaine.

23. Henri de Toulouse-Lautrec (1864–1901)
L'Anglais au Moulin Rouge, 1892
color lithograph
Delteil 12
18½ x 14⅝ in. (470 x 372mm)
Memorial Art Gallery
Rochester, N.Y.
Anonymous Gift (81.41)

The Englishman, seen here with two of the dancers in the "Quadrille Réaliste," was an aspiring painter William Tom Warrener who left Paris around 1905 to manage his family's coal business in Lincoln, England. (Metropolitan Museum card catalogue.) The two dancers are "Rayon d'Or" (Golden Ray) and "La Sauterelle" (Grasshopper). A painting executed as a study for this lithograph is in the collection of the Metropolitan Museum.

24. Henri de Toulouse-Lautrec (1864-1901)
Les Vieilles Histoires, 1893
lithographic cover for a collection of songs
Delteil 18 $^{iii}/_{iii}$
13%6 x 21⅚6 in. (345 x 542mm)
From the collection of Mr. and Mrs. Herbert Schimmel

This cover design for a collection of songs by the poet Jean Goudezki (Goudey), set to music by Lautrec's cousin Désiré Dihau, shows the composer taking the poet Goudezki (humorously depicted as a muzzled bear on a leash) for a stroll along the Seine.

Dihau was a friend of Degas and owned his painting *Musicians of the Orchestra* in which Dihau, himself, was depicted. When Lautrec painted Dihau's portrait he asked "timidly and humbly if it did not suffer from comparison with Degas's." (Jourdain and Adhémar, *T-Lautrec,* Appendix, p. 92.)

Cat. No. 24

25. **Henri de Toulouse-Lautrec (1864–1901)**
Sagesse, 1893
lithograph
Delteil 22 $^i/_{ii}$
10 x 7½ in. (254 x 190mm)
From the collection of Mr. and Mrs. Herbert D. Schimmel

Misia Natanson and the historian Louis-Numa Baragnon are depicted on this cover for a piece of sheet music from the *Vieilles Histoires* series for which Lautrec also designed the cover (cat. no. 24). "Sagesse" is the title of the song with lyrics by poet Jean Goudezki and music by Lautrec's cousin Désiré Dihau. Numa Baragnon, an occasional contributor to the *Revue Blanche,* was editor-in-chief of *Siècle.* He was celebrated among his friends for his enormous appetite, once having consumed seventy-two small patés before dinner (Jourdain and Adhémar, *T-Lautrec,* Appendix, p. 87.)

26. **Henri de Toulouse-Lautrec (1864–1901)**
Jane Avril, 1893
color lithographic poster
Delteil 345 $^i/_{ii}$
51³⁄₁₆ x 37⅜ in. (1300 x 950mm)
From the collection of Mr. and Mrs. Herbert D. Schimmel

Lautrec made this poster for the debut of his friend the dancer Jane Avril at the Jardin de Paris. Self-taught as a dancer, this pale, fragile young woman relied "on her innate sense of rhythm and natural grace to carry her through."

> "Jane Avril was the only one of the Montmartre dancers who appreciated Lautrec's work and recognized that her fame was in part due to his pictures of her. She was of a serious turn of mind and could discuss books and pictures intelligently; Lautrec paid tribute to her artistic interests by portraying her examining prints in the colored lithograph which he designed for the cover of *L'Estampe Originale.*" (Douglas Cooper, *Toulouse-Lautrec,* p. 100.)

27. **Henri de Toulouse-Lautrec (1864–1901)**
Aristide Bruant in his Cabaret, 1893
color lithographic poster
Delteil 348 $^i/_{ii}$
50 x 36⁷⁄₁₆ in. (1270 x 925mm)
From the collection of Mr. and Mrs. Herbert D. Schimmel

Aristide Bruant was the founder, proprietor and host of *Le Mirliton,* one of a number of cabarets that flourished in Paris in the 1890's. Between performances of bawdy songs of his own composition Bruant entertained his customers by loudly insulting new arrivals. "Silence, messieurs," he cried as Lautrec and his friends entered, "here is the great painter Toulouse-Lautrec with one of his friends and a mackerel whom I do not know." (Maurice Donnay quoted in Jourdain and Adhémar, *T-Lautrec,* "Répertoire, Notices et Tables," p. 89.)

Described as having "the face of an emperor" and a voice "superb and brutal," Bruant customarily dressed, as Lautrec represents him here, in corduroy with a black cloak, boots, a broad brimmed hat and a long red scarf.

This is the first state of the poster before the addition of the words "*Aristide Bruant dans son cabaret.*"

28. **Henri de Toulouse-Lautrec (1864–1901)**
Un Monsieur et Une Dame, 1893 (Program for "L'Argent")
color lithograph
Delteil 15, $^{ii}/_{ii}$
12⁹⁄₁₆ x 9½ in. (319 x 241mm)
The Atlas Foundation

L'Argent, a play by Emile Fabre, opened at the Théâtre Libre October 8, 1893. The dominating female in the foreground is "Mme. Reynard," a central figure in this cynical comedy about a disputed inheritance.

29. **Henri de Toulouse-Lautrec (1864–1901)**
Mme. Abdala, 1893
lithograph
Delteil 33
10⅝ x 7¾ in. (270 x 197mm)
Memorial Art Gallery
Rochester, N.Y.
Granger A. Hollister Fund (36.50)

The subject is a singer who appeared at the popular café-concert "Les Ambassadeurs" in 1892. Lautrec may have been influenced in his use of strong light and dark contrasts here by the woodcuts his friend Félix Vallotton had begun to make two years earlier.

This lithograph is one of eleven executed by Lautrec for an album titled *Le café-concert* published by *L'Estampe originale* with a text by Georges Montorgueil. The artist H. G. Ibels also contributed eleven lithographs to the album.

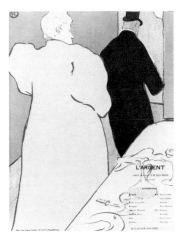

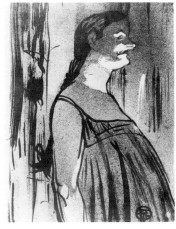

Cat. No. 28 Cat. No. 29

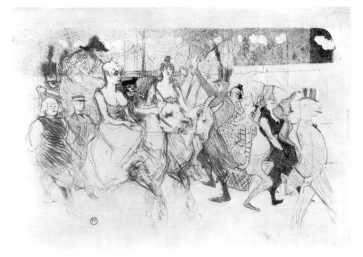

Cat. No. 31

30. Henri de Toulouse-Lautrec (1864–1901)
Le Salon du Chasseur de Chevelures, 1894
From the collection of Mr. and Mrs. Herbert D. Schimmel

The *Chasseur des Chevelures* (*Scalp Hunter*) was a humorous supplement to the *Revue Blanche* that appeared monthly in 1893 and 1894. It was edited by Tristan Bernard ("Informateur du possible") and Pierre Véber ("Déformateur du réel") and featured their writings as well as contributions from other *Revue Blanche* authors including Jules Renard and Romain Coolus. Félix Vallotton contributed a number of woodcut portraits as illustrations for Coolus's "*Petit Tussaud du Rondel*" ("Little Wax Museum of the Rondel") that appeared in several 1894 issues.

The bound volume exhibited here contains every issue of the *Chasseur des Chevelures* but is opened to the June, 1894, issue illustrated by Toulouse-Lautrec.

31. Henri de Toulouse-Lautrec (1864–1901)
Une redoute au Moulin-Rouge, 1894
lithograph
Delteil 65
11¹¹⁄₁₆ x 18⅛ in. (297 x 460mm)
Memorial Art Gallery
Rochester, N.Y.
Marion Stratton Gould Fund (59.44)

At the center of this procession of performers at the Moulin Rouge are two women: the blonde is the clowness Cha-U-Kao, the brunette, the dancer La Goulue ("The Glutton") immortalized by Lautrec in numerous paintings and prints.

"The Moulin Rouge, a music hall in the Boulevard de Clichy, was opened in October of 1889. It had an immediate and sensational success and was frequented by a fashionable public. Apart from the main dance floor, with a *promenoir* down each side and a gallery above for spectators, there was a large garden behind in which the crowds could sit or stroll. The nightly performance began with a concert of comic or sentimental songs . . . but the main attraction (between ten o'clock and midnight) was the dancing . . . performed by the famous Montmartre dancers—La Goulue, Valentin, Grille d'Egoût, Môme Fromage and Jane Avril." (Douglas Cooper, *Henri de Toulouse-Lautrec,* New York, 1956, p. 88.)

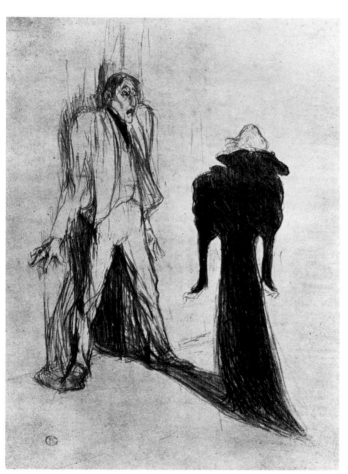

Cat. No. 33

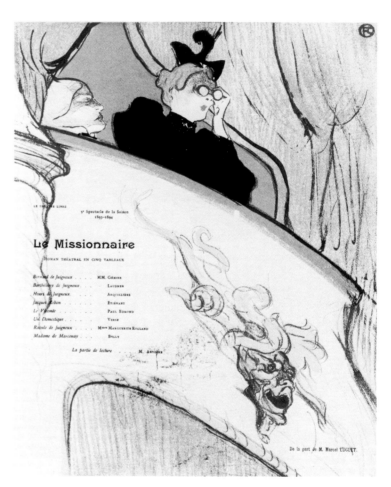

Cat. No. 34

Cat. No. 35

32. **Henri de Toulouse-Lautrec (1864–1901)**
Program for "Chariot de Terre Cuite," 1894
lithograph
Delteil 77, ii/ii
17¼ x 11 in. (440 x 280mm)
The Atlas Foundation

Chariot de Terre Cuite, Victor Barrucaud's adaptation of a Sanskrit drama, opened at the Théâtre de l'Oeuvre on January 22, 1895. In this program Lautrec depicts Félix Fénéon delivering the prologue.

 Fénéon served as Editorial Secretary of the *Revue Blanche* from 1895 until publication ceased in 1903. The year before he joined the *Revue Blanche* Fénéon had been arrested and imprisoned on suspicion of being a militant anarchist. Mallarmé was one of those who testified on Fénéon's behalf and he was ultimately acquitted.

 Although he wrote relatively little, Fénéon is regarded as one of the most perceptive and influential art critics of the day. He was an early champion of the painter Georges Seurat and organized the posthumous one-man exhibition of his work held in the *Revue Blanche* offices in 1900.

33. **Henri de Toulouse-Lautrec (1864–1901)**
Lugné-Poë in "L'Image," 1894
lithograph, proof on Japan paper
Delteil 57
12¼ x 8⅛ in. (312 x 228mm)
From the collection of Mr. and Mrs. Herbert D. Schimmel

Lugné-Poë is depicted here as he appeared in the February 1894 Théâtre de l'Oeuvre production of Maurice Beaubourg's *L'Image.* Lugné-Poë played Marcel, an idealist novelist obsessed by the image of the ideal woman. At the end of the play Marcel kills his wife because of her inability to live up to his ideal. Lautrec records the actor's evocation of Marcel's hallucination.

 The playwright Maurice Beaubourg also contributed articles to the *Revue Blanche.* A program for this production was designed by Vuillard (cat. no. 98.)

34. **Henri de Toulouse-Lautrec (1864–1901)**
La Loge au Mascaron Dore, 1894 (Program for "Le Missionnaire")
color lithograph
Delteil 16, ii/ii
12 x 9½ in. (305 x 241mm)
The Atlas Foundation

This color lithograph served as the program for *Le Missionnaire* by Marcel Luguet, André Antoine's last production at the Théâtre Libre. It opened on April 26, 1894, and closed after only a few performances. Shortly thereafter Antoine relinquished control of the organization he had created seven years earlier. The Théâtre Libre's role as the primary forum for avant-garde drama in Paris was taken over by Lugné-Poë's Théâtre de l'Oeuvre which inclined toward symbolism in opposition to the realist approach Antoine had championed.

 The young man depicted in this print is Lautrec's friend the English artist Charles Conder. The woman is unidentified.

35. **Henri de Toulouse-Lautrec (1864–1901)**
Lugné-Poë and Bady in "Au-Dessus des Forces Humaines," 1894
lithograph
Delteil 55
11⁵⁄₁₆ x 9⁷⁄₁₆ in. (288 x 240mm)
From the collection of Mr. and Mrs. Herbert D. Schimmel

In February, 1894, Aurélien Lugné-Poë, actor-manager of the avant-garde Théâtre de l'Oeuvre, and the Belgian actress Berthe Bady appeared together in a production of Norwegian playwright Bjornstjerne Bjornson's drama *Au-Dessus des Forces Humaines, Part I.* Bady, whose portrait Lautrec painted in 1897, was described by *Revue Blanche* contributor Jules Renard as "lively, nervous, with eyes like inkwells. She claims she weeps secretly several times a night." (Jourdain and Adhémar, *T-Lautrec,* Appendix, p. 86.) Vuillard designed a program for this production (cat. no. 97).

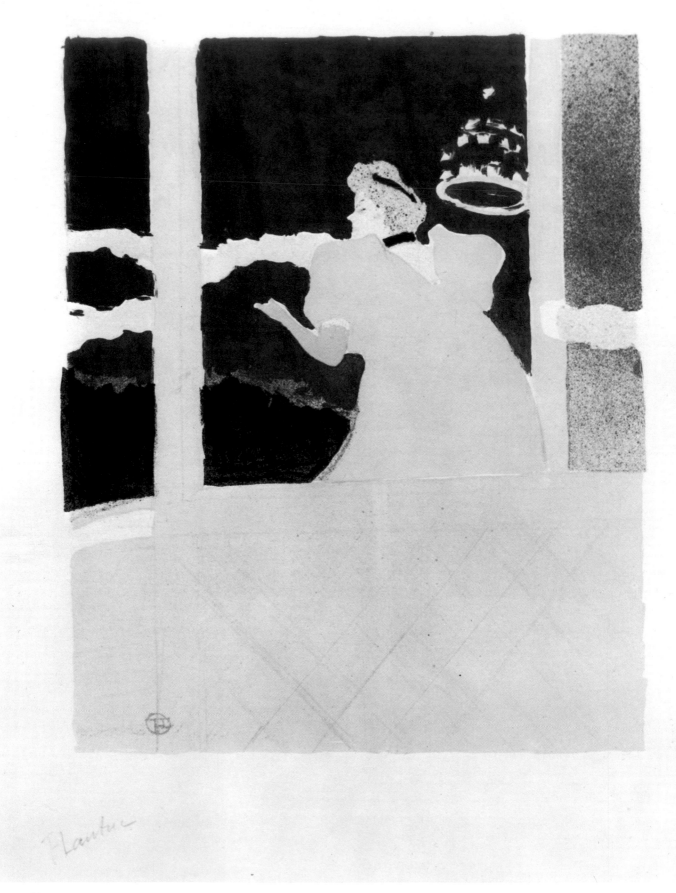

Cat. No. 36

70

Cat. No. 38

36. **Henri de Toulouse-Lautrec (1864–1901)**
Aux Ambassadeurs, 1894
color lithograph
Delteil 68
11 ⅞ x 9¹¹⁄₁₆ in. (302 x 246mm)
Memorial Art Gallery
Rochester, N.Y.
Anonymous Gift (82.40)

This six-color lithograph appeared in 1894 as part of the sixth album of prints published under the title *L'Estampe originale* by André Marty who the following year produced the *Album de la Revue Blanche.*

"Les Ambassadeurs" was a noisy café-concert on the Champs-Élysées where the public came more to see and be seen than to hear the performers, one of whom is seen here silhouetted against the sky in this partly open pavillion. Lautrec no doubt had in mind when executing this print his idol Degas's brilliant black and white lithograph *Mlle. Becat aux Ambassadeurs* of two decades earlier.

37. **Henri de Toulouse-Lautrec (1864–1901)**
May Milton, 1895
color lithographic poster
Delteil 356 (trial proof before color)
30⅞ x 23½ in. (785 x 597mm)
From the collection of Mr. and Mrs. Herbert D. Schimmel

May Milton, an English dancer whom Lautrec met in 1895, was a close friend of Jane Avril's. "Her pale almost clownish face, rather suggestive of a bull-dog, had nothing with which to rivet attention," wrote Lautrec's biographer and boyhood friend Maurice Joyant. This is a rare trial proof before the addition of color.

38. **Henri de Toulouse-Lautrec (1864–1901)**
NIB, 1895
lithograph
Delteil 99
From the collection of Mr. and Mrs. Herbert D. Schimmel

NIB was a humorous supplement to the *Revue Blanche.* This issue, which appeared in January, 1895, had a text by Tristan Bernard accompanied by Lautrec's lithographic illustrations. Depicted on one page are Footit and Chocolat, clowns from the popular "New Circus." On the cover is a smart young man at the seaside wearing a straw boater and holding his Kodak.

George Eastman's enterprise had made snapshot photography possible and it was enthusiastically practiced by many in the *Revue Blanche* circle, among them Edouard Vuillard:

Vuillard owned a camera, a Kodak. It was an ordinary model, one of the bellows type. It was a part of Vuillard's household. Its place was on the sideboard in the dining room. Sometimes, during a conversation, Vuillard would go to get it and resting it on some furniture or even the back of a chair, oblivious of its view finder, would point the lens in the direction of the image he wished to record: he would then give a brief warning, "Hold it please" and we would hear the clic . . . cloc of the time exposure. The camera was then returned to its place, and Vuillard walked back to his seat. (Jacques Salomon, *Vuillard et son Kodak* (exhibition catalogue), The Lefevre Gallery, London, 196?.)

Annette Vaillant, daughter of Alfred Natanson, remembered that Vuillard and her father had identical cameras and shared the new rage for snapshot photography. (*Ibid.*)

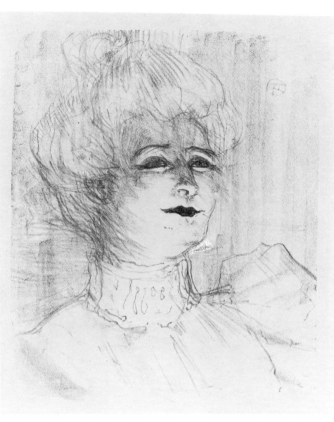

Cat. No. 39

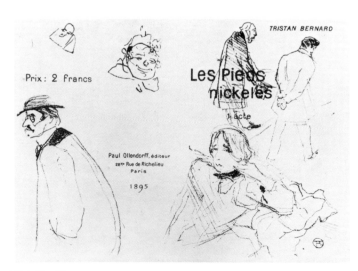

Cat. No. 41

39. **Henri de Toulouse-Lautrec (1864–1901)**
Jeanne Hading, 1895?
lithograph
Delteil 158
11⅜ x 9⅝ in. (289 x 245mm)
Memorial Art Gallery
Rochester, N.Y.
Gift of Mr. and Mrs. Irving S. Norry (69.10)

Jeanne Hading was the stage name of the Belgian actress Jeanne Alfrédine Trefouret, who was a celebrated beauty. The print is one of a series of thirteen portraits of actors and actresses produced by Lautrec around 1895.

40. **Henri de Toulouse-Lautrec (1864–1901)**
La Revue Blanche, 1895
color lithographic poster
Delteil 355
51³⁄₁₆ x 37⅜ in. (1300 x 950mm)
From the collection of Mr. and Mrs. Herbert D. Schimmel

The young woman depicted here is Misia Natanson, the "muse" of the *Revue Blanche.* She and her husband Thadée were at the center of the social circle of young artists, writers, musicians and intellectuals that formed around the review. Her swaying pose is explained by the fact that she is on ice skates. The rim of the circular skating rink appears near the top of the print. On an early state of this poster, below the monogram, is the tiny full-length figure of another female skater, probably the "professional beauty" Liane de Lancy depicted by Lautrec at the skating rink Palais de Glace in a drawing of 1896.

41. **Henri de Toulouse-Lautrec (1864–1901)**
Les Pieds Nickelés, 1895
lithographic book cover
Delteil 128
7½ x 8¹³⁄₁₆ in. (190 x 225mm)
From the collection of Mr. and Mrs. Herbert D. Schimmel

Lautrec executed this cover for the publication of his friend Tristan Bernard's one-act comedy *Les Pieds Nickelés* which was first performed at the Théâtre de l'Oeuvre in March of 1895. The lower figure on the front cover is said to represent Misia Natanson, although the resemblance is difficult to see.

Bernard contributed a number of articles to the *Revue Blanche* in the 1890's. He and Lautrec became acquainted in the milieu of that publication and were drawn together by a common interest in sports, especially the new rage for bicycling. Bernard was editor of the "Journal des Velocipédistes" and a director of the Vélodrome Buffalo, a stadium where bicycle races were held.

Cat. No. 42

Cat. No. 42a

42. Henri de Toulouse-Lautrec (1864–1901)
Prospectus Program for Théâtre de l'Oeuvre, 1895-96
lithograph
Delteil 149 $^{i}/_{ii}$
8¼ x 13⅜ in. (210 x 340mm)
From the collection of Mr. and Mrs. Herbert D. Schimmel

42a. Henri de Toulouse-Lautrec (1864–1901)
Prospectus Program for Théâtre de l'Oeuvre, 1895-96
lithograph
Delteil 149 $^{ii}/_{ii}$
8¼ x 13⅜ in. (210 x 340mm)
The Atlas Foundation

Lautrec designed this nocturnal scene of a ship at sea for the cover of a three-page prospectus program for the 1895-96 season of the Théâtre de l'Oeuvre. In addition to a trilingual text the prospectus includes prints by Vuillard, Vallotton, Denis, Doudelet and De la Gandara. Vallotton's woodcut portrait of Ibsen evidently served as the basis for the portrait incorporated by the Norwegian artist Edvard Munch into his 1897 program cover for the Théâtre de l'Oeuvre production of Ibsen's *Jean Gabriel Borkman* (cat. no. 113). The rare first state of Lautrec's print before the addition of lettering is exhibited here together with the published second state.

Cat. No. 43

Cat. No. 44

43. Henri de Toulouse-Lautrec (1864–1901)
Oscar Wilde and Romain Coolus, 1896
lithograph
Delteil 195, $^{iv}/_{iv}$
11$^{13}/_{16}$ x 19$^{5}/_{16}$ in. (300 x 490mm)
The Atlas Foundation

In this program for the February 11, 1896, Théâtre de l'Oeuvre production of Oscar Wilde's *Salomé* and *Raphael* (on which Wilde collaborated with *Revue Blanche* critic Romain Coolus), Lautrec depicts the two authors, Wilde at the right, Coolus at left.

Lautrec and his colleagues at the *Revue Blanche* sympathized with Wilde during his prosecution and imprisonment in England on charges of immorality resulting from his liaison with the young Lord Alfred Douglas. These two plays were performed in Paris during Wilde's two-year imprisonment in Reading Gaol.

Wilde's only contribution to the *Revue Blanche* appeared in 1899: *Poémes en prose.* Romain Coolus, on the other hand, was the review's most faithful author with articles in nearly every issue from 1891 to 1903.

44. Henri de Toulouse-Lautrec (1864–1901)
Program for "Le Gage," 1897
lithograph
Delteil 212 $^{ii}/_{ii}$
11$^{9}/_{16}$ x 8$^{11}/_{16}$ in. (294 x 221mm)
The Atlas Foundation

The bearded gentleman depicted on this program for *Le Gage* by Frantz Jourdain and *Rosmersholm* by Ibsen (produced at the Théâtre de l'Oeuvre January 22, 1898) is the playwright Jourdain who was an architect and later served as president of the avant-garde Salon d'Automne. Jourdain also wrote art criticism in which he enthusiastically defended the new and daring. He was an early admirer of Lautrec's work.

Cat. No. 45

Cat. No. 46

45. **Henri de Toulouse-Lautrec (1864–1901)**

Program for Benefit for Gémier, 1897
lithograph
Delteil 221 $^{ii}/_{ii}$
12½ x 19⅜ in. (318 x 492mm)
The Atlas Foundation

This portrait of the theatrical producer-director André Antoine, founder of the Théâtre Libre, was created for the program of a benefit for the celebrated actor Firmin Gémier, held December 23, 1897.

> In 1887 André Antoine, a clerk with the Paris Gas Company and an amateur actor, felt the need to give those playwrights who had rejected star-studded, elaborately produced romantic and historial dramas an opportunity to be seen and heard. With virtually no money, he gathered a group of fellow amateurs, and on March 30, 1887, in a small Montmartre hall . . . opened a showcase for playwrights whose plays could be produced nowhere else. Thus was the Théâtre Libre born. (D. Rubenstein, *The Avant-Garde in Theatre and Art: French Playbills of the 1890's* [exhibition catalogue] Smithsonian Institution Traveling Exhibition Service, 1972, p. 4.)

The relatively realistic style of Lautrec's lithograph is in keeping with the realist drama favored by Antoine. It was against this tradition that Lugné-Poë reacted in creating his symbolist Théâtre de l'Oeuvre in 1893.

46. **Henri de Toulouse-Lautrec (1864–1901)**

L'Etoile rouge, 1898
lithographic book cover
Delteil 231
8¹³⁄₁₆ x 4⁹⁄₁₆ (224 x 116mm)
From the collection of Mr. and Mrs. Herbert D. Schimmel

Paul Leclercq, the author of *L'Etoile rouge,* was one of the original founders of the *Revue Blanche.* He is depicted here standing at the foot of the bed, hands in his pockets.

This volume is number one of a special limited edition of only thirty examples and bears inscriptions on the inside cover from Leclercq and Lautrec to Misia and Thadée Natanson.

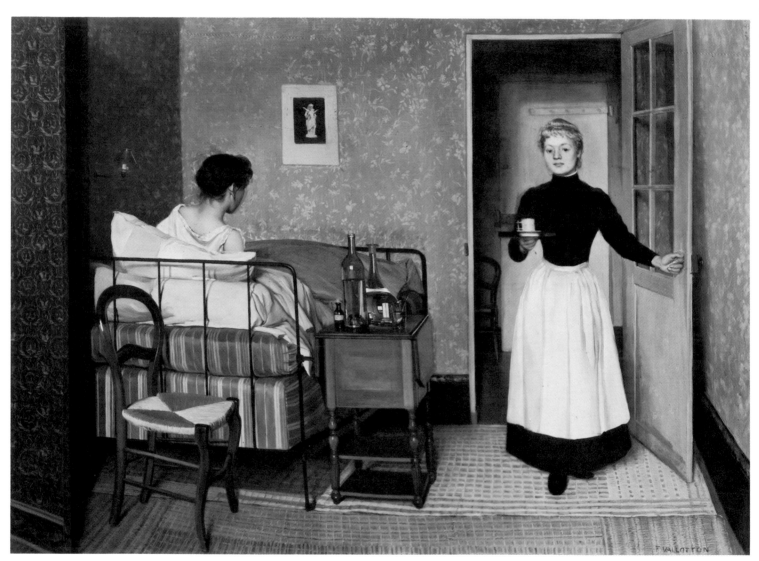

Cat. No. 47

Cat. No. 48

47. Félix Vallotton (1865–1925)
The Sick Girl (La Malade), 1892
oil on canvas
29⅛ x 39⅜ in. (840 x 1000mm)
Lent by Galerie Paul Vallotton, Lausanne, Switzerland

This pre-Nabi period painting demonstrates Vallotton's mastery of
the academic painting style and techniques taught at the Académie
Julian in Paris where he began his studies at age seventeen.
Comparison with works like *The Fourteenth of July at Etretat* (cat.
no. 52) reveal the degree to which, later in the decade, he came
under the influence of his fellow Nabis and, indirectly, of Gauguin.
Vallotton's painting after the turn of the century seems to be a
synthesis of the two modes.

48. Félix Vallotton (1865–1925)
The Crowd, 1894
oil on panel
10%₁₆ x 13¾ in. (268 x 349mm)
Allen Memorial Art Museum, Oberlin College
Oberlin, Ohio
Elisabeth Lotte Franzos Bequest, 58.57

The crowded streets of Paris provided subject matter for many of
Vallotton's woodcuts: *L'Etranger* (cat. no. 63), *Le 1ᵉʳ Janvier* (cat.
no. 67), *La Manifestation* (cat. no. 59). Unlike the woodcuts,
however, this small painting makes no overt social or political state-
ment. In its decorative patterning and free brushwork this street
scene resembles the compositions of Bonnard and Vuillard.

49. Félix Vallotton (1865–1925)
The Lie, 1897
oil on composition board
9¼ x 13 in. (235 x 330mm)
The Baltimore Museum of Art
The Cone Collection, formed by Dr. Claribel Cone
and Miss Etta Cone of Baltimore, Maryland (BMA 1950.189)

This painting is related to the woodcut of the same title from
Vallotton's famous *Intimités* series, published by the *Revue Blanche*
in 1898 (cat. nos. 69, 70, 71, 72). Vallotton's painting of the mid-
1890's shares to some degree the free brushwork and loose paint
handling favored by his friends Bonnard and Vuillard, although his
woodcut style of the same period is a model of clarity and precision.
Shortly after the turn of the century Vallotton abandoned print-
making and reverted a painting style marked by the sharp definition
that had characterized his woodcuts and his earlier paintings.

50. Félix Vallotton (1865–1925)
Portrait of Thadée Natanson, 1897
oil on composition board
26³⁄₁₆ x 18⅞ in. (665 x 480mm)
Lent by Petit Palais Musée, Geneva, Switzerland

Although nominally only a member of the editorial committee of the
Revue Blanche, Thadée Natanson was, in fact, the single individual
most closely identified with the publication. According to Paul
Leclercq, one of the review's original founders, "it was through the
intuition and influence of Thadée Natanson that *La Revue Blanche*
became celebrated."

Vallotton had begun to contribute woodcuts to the *Revue
Blanche* in 1894, and by 1897 when this portrait was painted had
become an intimate of the Natansons' social circle.

The stiff frontality of the pose, the precision with which the
face is rendered and even the interior setting with a window open-
ing onto a landscape all recall the portraits of fifteenth and early
sixteenth century Northern masters whose "primitive" qualities
critics also admired in Vallotton's woodcuts.

51. Félix Vallotton (1865–1925)
Women with Cats, 1898(?)
oil on cardboard
16⅛ x 20½ (410 x 520mm)
Lent by Galerie Paul Vallotton, Lausanne, Switzerland

The subject of a nude woman playing with a cat was treated by
Vallotton in a woodcut of 1896, titled *Laziness (La paresse).* Here a
nude girl teases a kitten with a ball of yarn while an older woman,
also nude, watches. The intensity of the older woman's attention
echoes that of the cat crouched in the foreground watching the
kitten at play.

The flat patterning and the precision of outline evident
here may reflect the influence of Vallotton's woodcut style on his
painting.

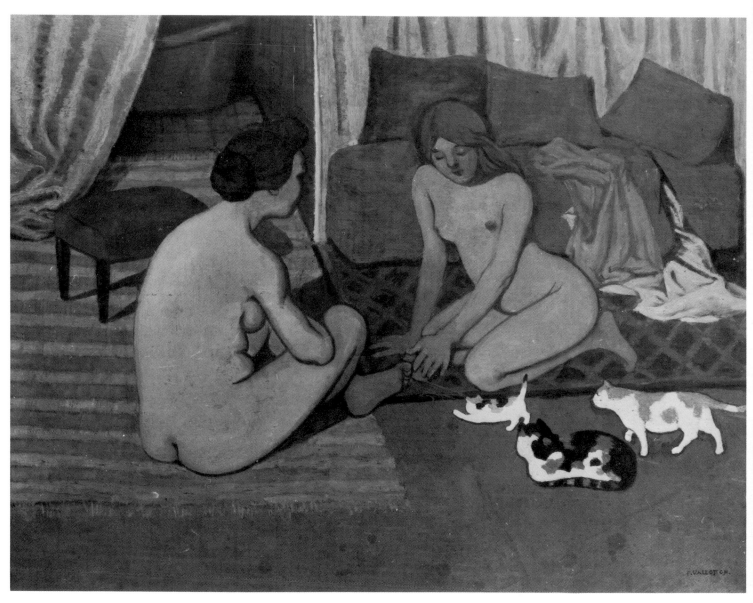

Cat. No. 51

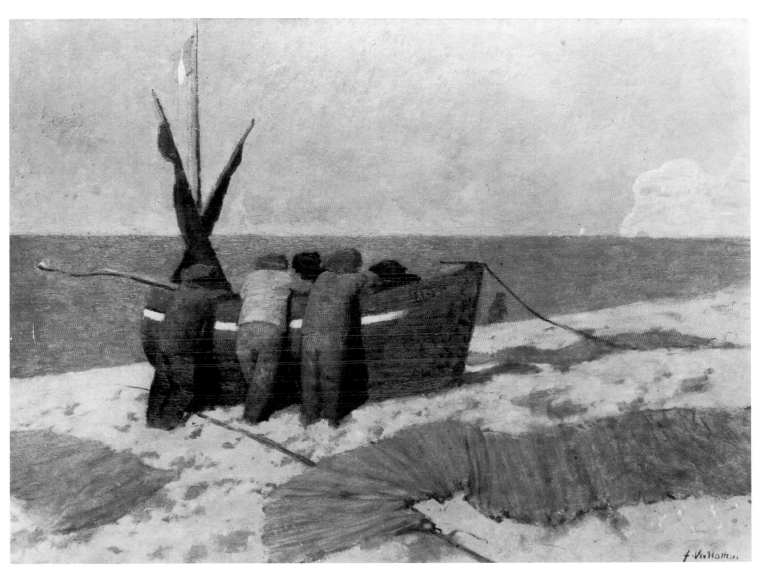

Cat. No. 52

52. Félix Vallotton (1865–1925)
The 14th of July at Etretat, 1899
oil on cardboard
19¼ x 23⅝ (490 x 600mm)
Lent by Galerie Paul Vallotton, Lausanne, Switzerland

Vallotton painted this view of the beach at the seaside resort of Etretat in the summer of 1899 shortly after his marriage to the daughter of the art dealer Bernheim-Jeune. The couple were visited at Etretat that summer by Vuillard and Thadée and Misia Natanson.

53. Félix Vallotton (1865–1925)
Self-Portrait, 1891
woodcut
Vallotton and Goerg 82
10 x 6⅜ in. (254 x 162mm)
The Art Institute of Chicago
Gift of Marjorie Kovler (1968.30)

This early self-portrait appeared as the frontispiece to Octave Uzanne's 1892 article on Vallotton in *L'Art et l'Idée.* The mountainous landscape suggests Vallotton's Swiss homeland and the manner in which buildings, clouds and figures are stylized indicates that Vallotton had carefully studied the early woodcuts of Albrecht Dürer and other fifteenth- and sixteenth-century Northern masters.

54. Félix Vallotton (1865–1925)
The Assassination (L'Assassinat), 1893
woodcut
Vallotton and Goerg 113
9¾ x 13 in. (248 x 330mm)
The Art Institute of Chicago
The Joseph Brooks Fair Collection (1947.456)

This is an early manifestation of Vallotton's interest in the violent aspects of *la vie parisienne* so conspicuously absent from the work of Bonnard and Vuillard. In such works Vallotton is closer to Lautrec in his exploration of the darker side of modern urban life. The title, with its political overtones, may be an indication of Vallotton's interest in Anarchism. By showing only the victim's forearm and hiding the attacker's face behind the headboard of the bed the artist suggests the chilling impersonality of ideologically inspired murder.

55. Félix Vallotton (1865–1925)
The Scuffle (La Rixe or *Scene de café),* 1892
woodcut
Vallotton and Goerg 101
6¹¹⁄₁₆ x 9¹³⁄₁₆ (170 x 250mm)
Lent by Galerie Paul Vallotton, Lausanne, Switzerland

There seems to be no hidden historical or symbolic significance to this depiction of a café brawl. Vallotton's striking graphic image has the immediacy of a modern news photograph.

56. Félix Vallotton (1865–1925)
The Anarchist (L'Anarchiste), 1892
woodcut (posthumous impression)
Vallotton and Goerg 104
6¾ x 9¹³⁄₁₆ (171 x 250mm)
Lent by Galerie Paul Vallotton

The brutality with which Paris police broke up an anarchist demonstration in 1891 precipitated a series of terrorist bombings which in turn resulted in arrests and executions. Although not himself an anarchist, Vallotton—like many of the artists and intellectuals in the circle of the *Revue Blanche*—sympathized with the radicals who defied the authority of the state.

Here, although the young suspect clearly is the protagonist, his hand-in-the-pocket gesture (to produce a knife? a gun? some form of identification?) introduces a note of ambiguity.

57. Félix Vallotton (1865–1925)
The Print Collectors (Les amateurs d'estampes), 1892
woodcut
Vallotton and Goerg 107
9⅝ x 12½ in. (245 x 317mm)
The Art Institute of Chicago
Charles Deering Collection (1927.3126)

This woodcut was commissioned and used as an advertisement by the print dealer Edmond Sagot, who early showed Vallotton's work and published Julius Meier-Graefe's monograph on the artist in 1898. The crowd has gathered to examine prints exhibited in the windows of Sagot's establishment. The number and enthusiasm of the print collectors seen here no doubt are evidence of wishful thinking on the part of the artist and his dealer.

58. Félix Vallotton (1865–1925)
Le Bon Marché, 1893
woodcut
Vallotton and Goerg 116
8 x 10¾ in. (202 x 257mm)
The University of Michigan Museum of Art

Le Bon Marché was a popular Parisian department store. Its large, open spaces filled with shoppers provided an indoor equivalent of the spectacle of jostling humanity that Vallotton frequently depicted in his street scenes.

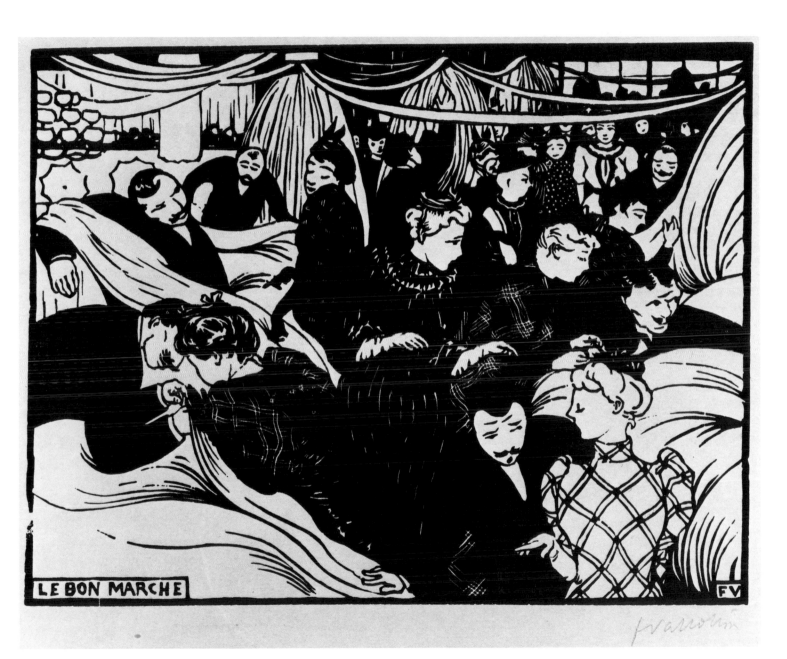

LE BON MARCHE

Cat. No. 58

59. **Félix Vallotton (1865–1925)**
The Demonstration (La Manifestation), 1893
woodcut
Vallotton and Goerg 110
8 x 12⅗₆ in. (203 x 320mm)
Lent by Galerie Paul Vallotton, Lausanne, Switzerland

Like *L'Anarchiste* (cat. no. 56) and *La Charge* (cat. no. 60) this woodcut deals with police suppression of political dissent. Only here the police are unseen, their menacing presence inferred from the panicked flight of the crowd.

60. **Félix Vallotton (1865–1925)**
The Charge (La Charge), 1894
woodcut
Vallotton and Goerg 128
7⅞ x 10¼ in. (200 x 260mm)
The Art Institute of Chicago
Joseph Brooks Fair Collection (1947.458)

This print depicts the brutal police intervention that presumably precipitated the panicked flight of the crowd represented in *The Demonstration (La Manifestation)* (cat. no. 59). Street demonstrations occurred with some frequency in the 1890's as manifestations of social and political unrest. An anarchist assault in early November of 1892 claimed five victims and later that month Vallotton wrote to his brother: "Paris is pleasant, but the political malaise taints everything. Only anarchy profits from all this and no doubt we will soon see its effects here." (Guisan and Jakubec, *Félix Vallotton,* p. 85.)

61. **Félix Vallotton (1865–1925)**
Romain Coolus, 1894
woodcut
Vallotton and Goerg 132
Lent by Galerie Paul Vallotton, Lausanne, Switzerland

Romain Coolus was one of the most faithful and prolific contributors to the *Revue Blanche.* The commission of this woodcut reportedly was obtained for Vallotton from Coolus by their mutual friend Vuillard.

62. **Félix Vallotton (1865–1925)**
The Three Bathers (Les trois baigneuses), 1894
woodcut
Vallotton and Goerg 133
7⅜ x 4⅜ in. (183 x 112mm)
Lent by Jane Voorhees Zimmerli Art Museum,
Rutgers—The State University of New Jersey
New Brunswick, N.J.
David A. and Mildred H. Morse Art Acquisition Endowment
(81.33.34)

This print, published as the frontispiece for the *Revue Blanche* in February, 1894, was the first of many commissions executed by Vallotton for that publication. *The Three Bathers* also was included in the album of the *Revue Blanche* published the following year.

63. **Félix Vallotton (1865–1925)**
The Stranger (L'Étranger), 1894
woodcut
Vallotton and Goerg 137
8¹³⁄₁₆ x 7 in. (224 x 179mm)
The Baltimore Museum of Art
The Cone Collection, formed by Dr. Claribel Cone and
Miss Etta Cone of Baltimore, Maryland

It has been suggested that this print represents a crowd at the Folies-Bergère and that the two figures in the foreground are the cabaret performer Jane Avril and the male dancer Valentin de Désossé. (St. James, *Vallotton graveur,* p. 29.) While the woman does bear some resemblance to Jane Avril (see Lautrec's *Divan Japonais* poster, cat. no. 20), the predatory intensity with which she engages her partner, as other women flirt with or are fondled by other tophatted gentlemen, speaks more of solicitation than of a friendly social exchange.

64. **Félix Vallotton (1865–1925)**
Program for Père, 1894
lithograph
Vallotton and Goerg 53
9⅝ x 12½ in. (244 x 311mm)
The Atlas Foundation

This lithographic program for the December 14, 1893 Théâtre de l'Oeuvre production of August Strindberg's three-act tragedy *Père* includes advertisements for *L'Estampe originale* and for *La Revue Blanche,* the December issue of which carried an article on Strindberg by Henri Albert.

 On the right half of the sheet is a representation of a lithographer's shop in which artist and printer watch eagerly as the latter peels a proof away from the lithographic stone. On the left side of the sheet are represented characters from Strindberg's drama in which Lugné-Poë played the role of the pastor.

Cat. No. 64

65. Félix Vallotton (1865–1925)
At Age Twenty (A Vingt Ans), 1894
woodcut
Vallotton and Goerg 134
9⅝₆ x 13 in. (236 x 330mm)
The University of Michigan Museum of Art

Military service was compulsory for young Frenchmen in the 1890's. Although Vallotton as a Swiss citizen was exempt from French military service, his friends were not. Vallotton's ironic representation of military life has much in common with Bonnard's *La Parade*, painted in 1890 while the artist was on active duty. The unbuttoned fly of one of Vallotton's soldiers and the troop's generally disheveled appearance suggest Vallotton's lack of sympathy for governmental authority in general and the military in particular—an attitude shared by many of his colleagues at the *Revue Blanche* where anarchist sentiment was strong.

66. Félix Vallotton (1865–1925)
The Joyous Latin Quarter (Le Joyeux Quartier latin), 1895
woodcut (posthumous impression)
Vallotton and Goerg 165
7 x 8¾ in. (178 x 223mm)
Lent by Galerie Paul Vallotton, Lausanne, Switzerland

The frenetic, puppetlike movements of these revelers and the mindless grimaces of the three whose faces are visible suggest that Vallotton saw the Latin Quarter as something less than an Elysium of unconstrained joy.

67. Félix Vallotton (1865–1925)
The First of January (Le 1ᵉʳ Janvier), 1896
woodcut
Vallotton and Goerg 167
7 x 8¹¹⁄₁₆ in. (179 x 221mm)
Cabinet des estampes, Geneva, Switzerland

Vallotton, like his friend Bonnard, found the streets of Paris an inexhaustible source of subject matter. But whereas Bonnard took delight primarily in the visual aspects of the ever-changing spectacle, Vallotton often emphasized the human drama continually unfolding there. Here the members of a prosperous bourgeois family, perhaps returning from New Year's mass, recoil in obvious distaste from a trio of importuning beggars.

This print appeared in the first volume of dealer Ambroise Vollard's *Album des peintres-graveurs* together with works by twenty-one other artists including Bonnard and Vuillard.

68. Félix Vallotton (1865–1925)
Les Rassemblements, 1896
book cover
From the collection of Mr. and Mrs. Herbert D. Schimmel

Les Rassemblements, subtitled *Physiologies de la rue,* was a collection of essays by more than a dozen *Revue Blanche* writers, with a prologue by Octave Uzanne and cover and illustrations by Vallotton. Uzanne had published one of the first enthusiastic appraisals of Vallotton's woodcuts in 1892: "What rest for our eyes, fatigued by all the preciosity of current printmaking, to see this primitive gravure, so amusing, so gay, so droll in these images in a style deliberately reactionary and crude compared with the majority of modern relief prints." (*L'Art et l'Idée,* February, 1892.)

In a witty acknowledgement of his involvement (as well of that of most of the book's authors) with the *Revue Blanche,* Vallotton includes on the back cover a kiosk bearing posters advertising that publication.

69. Félix Vallotton (1865–1925)
The Lie (*Le Mensonge*), 1897–1898
woodcut from *Intimités* series
Vallotton and Goerg 188
7 1/16 x 8 7/8 in. (179 x 225mm)
The Museum of Modern Art, New York
Gift of Abby Aldrich Rockefeller (by exchange) (191.54.1)

Toward the end of 1898 the *Revue Blanche* published and exhibited in its offices Vallotton's ten-woodcut series called *Intimacies* (*Intimités*). In the January, 1899 Thadée Natanson wrote:

> But what of the idea, or if you wish, the philosophy these images express? Ten times a man and a woman meet in all the attitudes where they can arrest the accidents, the stations of *la vie sentimentale*. They express every imaginable aspect of it, the naiveté and the ridiculousness, the hypocrisy and the lying, the cruelty and even that taste of death which is a part of our conception of love. One laughs, one murmurs, one is indignant, one shudders. The delicious, disturbing spectacle.

This and the following three prints are from a specimen set of the *Intimacies* series and show details sometimes lost in the published edition.

70. Félix Vallotton (1865–1925)
The Cogent Reason (*La Raison probante*), 1897–98
woodcut from *Intimités* series
Vallotton and Goerg 191
7 x 8 3/4 in. (178 x 223mm)
The Museum of Modern Art, New York
Gift of Abby Aldrich Rockefeller (by exchange) (191.54.4)

71. Félix Vallotton (1865–1925)
Extreme Measure (*Le Grand Moyen*), 1897–98
woodcut from *Intimités* series
Vallotton and Goerg 193
7 x 8 13/16 in. (178 x 225mm)
The Museum of Modern Art, New York
Gift of Abby Aldrich Rockefeller (by exchange) (191.54.6)

72. Félix Vallotton (1865–1925)
The Other's Health (*La santé de l'autre*), 1897–98
woodcut from *Intimités* series
Vallotton and Goerg 196
7 x 8 3/4 in. (178 x 223mm)
The Museum of Modern Art, New York
Gift of Abby Aldrich Rockefeller (by exchange) (191.54.9)

73. Félix Vallotton (1865–1925)
The Fireworks (*Le Feu d'artifice*), 1901
woodcut from *L'Exposition Universelle* series
Vallotton and Goerg 208
6 7/16 x 4 13/16 in. (164 x 122mm)
The Metropolitan Museum of Art, Rogers Fund, 1919

This is the last of a series of six woodcuts commissioned by the German publisher Otto Julius Bierbaum to commemorate the world's fair that opened in Paris on April 14, 1900. Although the Exposition Universelle was intended to celebrate the dawn of a new age, Vallotton characteristically chose to emphasize the angst that many experienced at the old century's end.

74. Edouard Vuillard (1868–1940)
Portrait of Lugné-Poë, 1891
oil on panel
9 1/2 x 10 1/2 in. (240 x 265mm)
Memorial Art Gallery
Rochester, N.Y.
Gift of Mr. Fletcher Steele

A classmate at the Lycée Condorcet, of Vuillard, Denis, and Roussel, Aurélien Lugné-Poë was involved in dramatics from his school days. When his friends entered the Académie Julian upon graduation from the Lycée, Lugné-Poë began studies at the Conservatoire de Musique et de la Declamation.

By 1891, when this portrait was painted, Lugné-Poë was sharing a small studio at 28 rue Pigalle with Bonnard, Vuillard and Denis:

> While my friends painted away, I bored them to distraction as I went over my parts for the Conservatoire or gave lessons then and there, in front of them. (*Le Sot du tremplin,* quoted in Russell, *Vuillard,* p. 80.)

In this delightful little portrait we see the future founder of the Théâtre de l'Oeuvre poring over a script, oblivious of the attention of his friend Vuillard. The poet May Sarton records that when she met Lugné-Poë some forty years later he "did not resemble the Vuillard portrait at all."

> The young man Vuillard caught thinking would never open a huge mouth and laugh that devouring laugh; nor did the man in the painting look like an elephant, as Lugné-Poë, with his great sensitive nose, his immense forehead and small sardonic eyes, certainly did." (*I Knew a Phoenix,* 1959, p. 169.)

75. Edouard Vuillard (1868–1940)
Seated Woman, c. 1895
oil on panel
8 7/16 x 6 3/8 in. (214 x 162mm)
Syracuse University Art Collection
(SU66.243)

The young woman depicted here may be the artist's sister Marie, who in 1893 married Vuillard's close friend the painter K. X. Roussel.

Cat. No. 75 Cat. No. 76

76. Edouard Vuillard (1868–1940)
Garden Overlooking the Sea, Cannes, c. 1896(?)
oil on board mounted on panel
11 x 13¼ in. (279 x 337mm)
Museum of Art, Carnegie Institute
Pittsburgh, Penn.
Museum Purchase: Gift of Mrs. Alan M. Scaife and Family, 1965.
(65.17.3)

This painting may date from the same period as the one of a similar
subject in the collection of the Metropolitan Museum believed to
have been painted in the summer of 1899 when Vuillard was a
guest of the Natansons in Cannes. Both paintings at one time
belonged to Thadée Natanson.

77. Edouard Vuillard (1868–1940)
The Luncheon (Le Dejuner), c. 1895–97
oil on cardboard
15¾ x 13¹³⁄₁₆ in. (400 x 351mm)
Yale University Art Gallery
The Katherine Ordway Collection (1980.12.17)

The woman in the foreground almost certainly is Misia Natanson
and the bearded man across the table, her husband Thadée, editor
of the *Revue Blanche.*

78. Edouard Vuillard (1868–1940)
Misia and Thadée Natanson, c. 1897
oil on paper mounted on canvas
36½ x 29¼ in. (927 x 743mm)
The Museum of Modern Art, New York
Gift of Nate B. and Frances Spingold, 1957
(270.57)

This portrait of Misia Natanson bathed in the glow of lamplight, with
husband Thadée relegated to a small space in the upper right
corner of the canvas, reveals Vuillard's affection for "the radiant and
sibylline Misia."

"I stayed with Thadée and Misia as long as I could," wrote
Vuillard to his friend Vallotton in November of the year in which this
painting is thought to have been executed, "because I was as happy
there as I am capable of being . . ." (Guisan and Jakubec, *Félix
Vallotton,* p. 170.)

The patterned wall covering is evidence that the room is
the same one represented in Vuillard's 1898 photograph of the
Natansons in their Paris apartment on the rue St. Florentin. Stuart
Preston suggests that Misia's "rapt contemplative air" indicates that
she is listening to music performed by an unseen pianist seated at
the draped instrument immediately behind her. (*Vuillard,* N.Y., n.d.,
p. 92.)

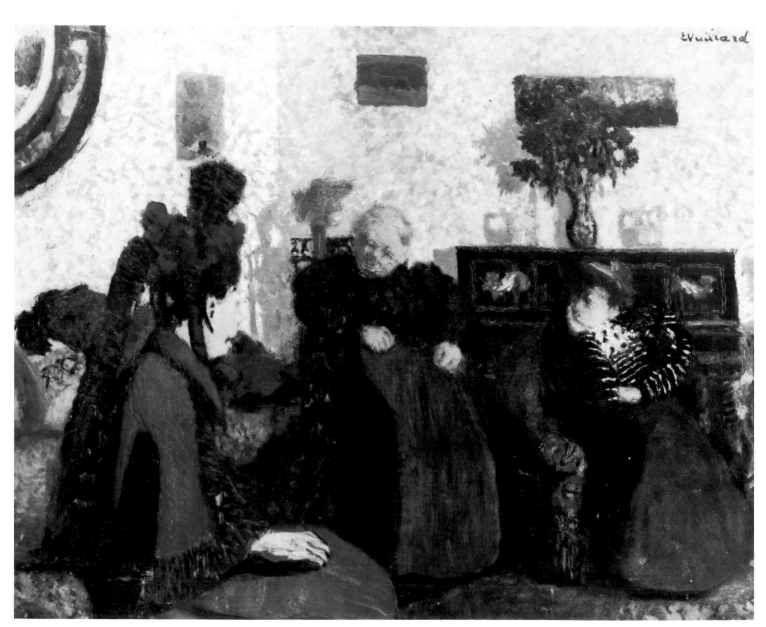

Cat. No. 79

79. Edouard Vuillard (1868–1940)
The Widow's Visit, 1899
oil on paper on board
19¾ x 24¾ in. (502 x 629mm)
Art Gallery of Ontario, Toronto
(Acc. 2422)

The Widow's Visit epitomizes Vuillard's ability to create compelling works of art from the seemingly insignificant events of everyday life. It recalls critic Gustave Geffroy's description of Vuillard as "an intimist with a delightful sense of humor" who "knows how to be funny and sad all at once . . ." (quoted in Russell, *Vuillard,* p. 27.)

80. Edouard Vuillard (1868–1940)
Portrait of Félix Vallotton, 1900(?)
oil on cardboard
11⁷⁄₁₆ x 7⅞ in. (270 x 210mm)
Lent by Galerie Paul Vallotton, Lausanne, Switzerland

Vallotton's casual attire supports the view that this informal portrait was painted during the summer of 1900 when Vuillard joined his friend on holiday in Switzerland.

81. Edouard Vuillard (1868–1940)
At the Revue Blanche (Portrait of Félix Fénéon), 1901
oil on board
18¼ x 22⅝ in. (464 x 575mm)
The Solomon R. Guggenheim Museum, New York

Editorial Secretary Félix Fénéon is seen here at his desk in the elegant rue Lafitte offices designed for the *Revue Blanche* by the Belgian architect Henri van de Velde in 1894. The following year van de Velde executed a series of interiors for the *Salon de l'Art Nouveau,* the gallery of Samuel Bing who later contributed two articles on Japanese art to the *Revue Blanche.*

 Although an anarchist in political persuasion, Fénéon was an efficient and industrious editor as is suggested by Vuillard's representation of his friend bent over his paper-strewn desk, wielding his editorial pen with intense concentration. The painting is inscribed from Vuillard to Fénéon.

82. Edouard Vuillard (1868–1940)
The Painter Ker-Xavier Roussel and his Daughter, c. 1904
oil on cardboard
23 x 21 in. (570 x 520mm)
Albright-Knox Art Gallery
Buffalo, N.Y.
Room of Contemporary Art Fund, 1943

Ker-Xavier Roussel and Vuillard became close friends during their school days at the Lycée Condorcet, and Roussel is said to have influenced Vuillard to become an artist. The two friends entered the Académie Julian in 1888 and the following year became founding members of the semi-secret artists' group, "Les Nabis." In 1893 Roussel married Vuillard's sister, Marie.

 This painting clearly reveals the change in Vuillard's painting style that took place after the turn of the century.

> From the poetic tensions that so mark the Mallarméan years, 1893 to about 1900, he moves into a more relaxed, ostensibly less melancholy mood. (. . .) The reduced tension is often charming. His looser brushwork and more obvious color arrangements often result in a delightful, even gay, picture which is far removed from the exquisite, brooding harmonies of many of his earlier, small panels. (Ritchie, *Vuillard,* p. 24.)

83. Edouard Vuillard (1868–1940)
Le Divan Rouge, c. 1905
oil on canvas
30¼ x 27¼ in. (768 x 692mm)
Lent Anonymously

Vuillard met Lucie Hessel, wife of the art dealer Jos Hessel, while visiting his friend Vallotton in Switzerland during the summer of 1900. Almost from the moment of their first meeting an intimacy was established between the artist and this formidable woman who "in her quasi-maternal way virtually ran his life."

> She protected him and promoted his work, took him on trips abroad, had him to stay in the summer, entertained him almost every evening in Paris, and after his mother's death, made a home for him at Les Clayes, her country house near Versailles. (Preston, *Vuillard,* p. 126.)

 By the time this painting was executed the *Revue Blanche* had ceased publication, Misia and Thadée Natanson were divorced and those who had formed the *Revue Blanche* circle had begun to go their separate ways.

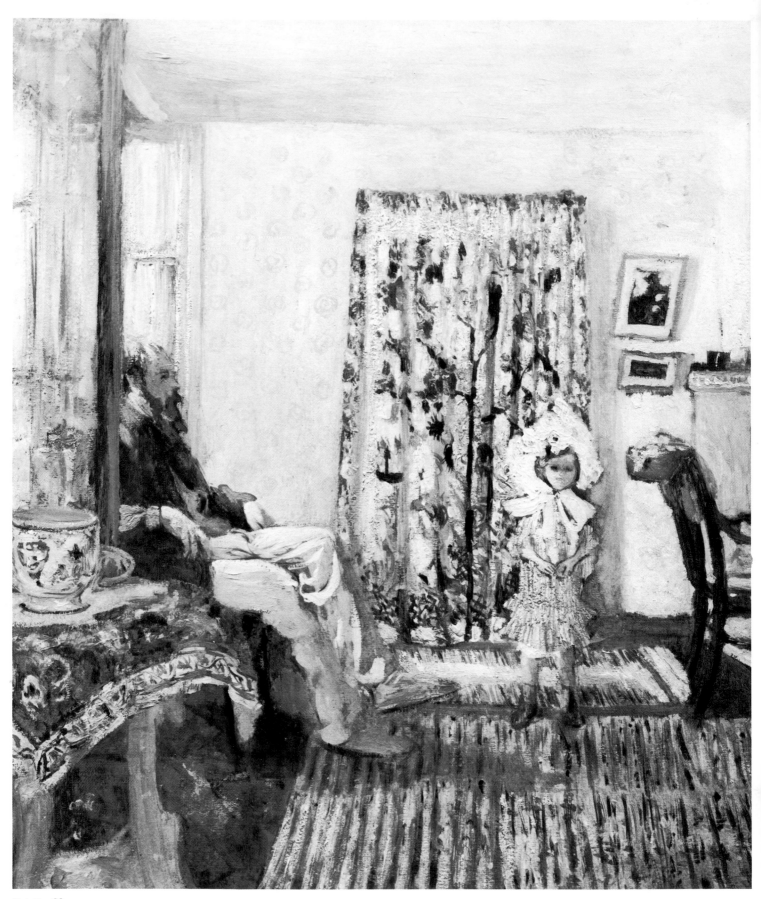

Cat. No. 82

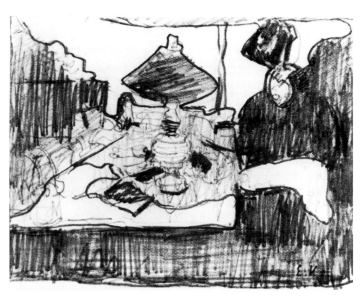

Cat. No. 89

84. Edouard Vuillard (1868–1940)
Grandmother Michaud, 1885
pastel
18¹⁵⁄₁₆ x 15¾ in. (481 x 400mm)
Lent by Mr. Alfred Ayrton

This drawing, evidently dating from Vuillard's school days at the Lycée Condorcet, demonstrates the artist's precocious talent. In its focus on an elderly woman seated in an interior it also gives an early indication of the sense of intimacy that was to characterize the artist's work until the end of the century.

85. Edouard Vuillard (1868–1940)
Self-Portrait, 1889
charcoal
8 x 6¾ in. (203 x 172mm)
Lent by Mr. Alfred Ayrton

This self-portrait of 1889, the year in which the artists' group called "Les Nabis" was formed, indicates Vuillard's concurrence with Mallarmé's dictum: "*to name* an object is to suppress three-quarters of the pleasure . . . *to suggest,* there is the dream."

86. Edouard Vuillard (1868–1940)
Design for a Program for the Théâtre Libre, c. 1890
ink and watercolor
11¹⁵⁄₁₆ x 8¼ in. (303 x 209mm)
Lent by Mr. Alfred Ayrton

Probably urged on by their mutual friend the actor Lugné-Poë, Vuillard and Bonnard both produced program designs for the Théâtre Libre that seem never to have been used. One of Vuillard's, however, eventually was accepted: a program for *Monsieur Bute* by Maurice Biolley (cat. no. 92).

87. Edouard Vuillard (1868–1940)
Profiles of the Theatre, c. 1892
brush and ink
16 x 12³⁄₁₆ in. (407 x 310mm)
Lent by Mr. Alfred Ayrton

This humorous brush and ink drawing bears the inscription "Concours de declamation/Conservatoire," and perhaps relates to Lugné-Poë's studies at the Conservatoire de Musique et Declamation. The male figure with arms crossed at upper center may, in fact, represent Lugné-Poë himself.

88. Edouard Vuillard (1868–1940)
Portrait Sketch of Coquelin *cadet*
pen and ink
4¾ x 4¾ in. (122 x 122mm)
Private collection, New York.

The actor Coquelin *cadet,* whom Vuillard met through Lugné-Poë, was to become one of the artist's first patrons.

89. Edouard Vuillard (1868–1940)
Petroleum Lamp, c. 1893
pencil
4⁵⁄₁₆ x 5⁷⁄₁₆ in. (110 x 138mm)
Lent by Mr. Alfred Ayrton

This tiny sketch demonstrates Vuillard's ability to weld the essential elements of a scene into a bold, decorative design in a few sure strokes.

Cat. No. 92

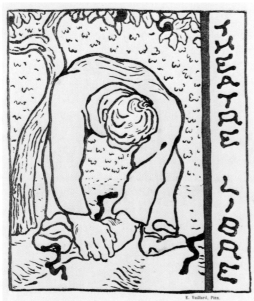

Cat. No. 93

90. Edouard Vuillard (1868–1940)
Young Woman Parting a Curtain, c. 1893
charcoal
5¹³⁄₁₆ x 5⅛ in. (148 x 130mm)
Lent by Mr. Alfred Ayrton

A painting of about the same date also depicting a woman opening an interior dividing curtain is in the collection of the National Gallery of Art, Washington, D.C. (*The Yellow Curtain,* Ailsa Mellon Bruce Bequest).

91. Edouard Vuillard (1868–1940)
Bonnard, c. 1900
charcoal
9 x 14⅝ in. (230 x 372mm)
Lent by Mr. Alfred Ayrton

Vuillard's charcoal sketch of his friend Bonnard recalls Thadée Natanson's description of the latter as a "slim, active man [who] seems tall, although he stoops a little and folds up on himself."

92. Edouard Vuillard (1868–1940)
Mme. Vuillard, c. 1900
pencil
4⁵⁄₁₆ x 5½ in. (110 x 140mm)
Lent by Mr. Alfred Ayrton

Vuillard's mother, who became a dressmaker upon her husband's death in order to support herself and her family, frequently appears in the artist's work. Often, as in this sketch, she is shown quietly sewing in the family apartment. *The Dressmaker* (*La Couturière*) (cat. no. 103), from Vuillard's lithographic album *Landscapes and Interiors,* depicts a similar scene but the subject appears to be a younger woman.

93. Edouard Vuillard (1868–1940)
Program for "Monsieur Bute," 1890
color lithograph
8⅜ x 7¼ in. (215 x 190mm)
The Atlas Foundation

Vuillard designed this, his first published theatre program, for the 1890-91 Théâtre Libre productions of *L'Amant de sa Femme* by Aurélien School, *Monsieur Bute* by Maurice Biolley, and *La Belle Opération* by Julien Sermet. The unusual subject, which seems to owe something to Van Gogh's peasants, or even Millet's, no doubt reflects the subject of one of the plays as well as the realist character of the Théâtre Libre productions.

Cat. No. 94

Cat. No. 95

94. **Edouard Vuillard (1868–1940)**
Program for "Rosmersholm," 1893
lithograph
Roger-Marx 16
9⁷⁄₁₆ x 12¹³⁄₁₆ in. (240 x 325mm)
The Atlas Foundation

Vuillard created this program for the premier production of Lugné-Poë's new Théâtre de l'Oeuvre: Ibsen's *Rosmersholm,* which opened October 6, 1893. Under Vuillard's direction Bonnard and Paul Sérusier prepared the sets. His artist friends, wrote Lugné-Poë, "agreed to work on the cold floor of the scenery storehouse . . ."

> How did our good friends escape death from bronchitis? It must be admitted that Vuillard and his companions, repainting at seven or eight in the morning the old flats we had picked up, risked their health and their youth in the undertaking. This scenery storehouse of the Bouffes-du-Nord, without a roof, was exposed to every wind and had no heating system of any kind . . . (*La Parade II, Acrobaties, Souvenirs et Impressions de Théâtre,* 1894-1902, Paris, 1932, p. 50, quoted in Rewald, *Pierre Bonnard,* pp. 23-24.)

Vuillard is credited with having selected the name for the new theatre through the process of opening a book at random and selecting the word "oeuvre" which caught his eye on the page before him. (*The Avant-Garde in Theatre and Art,* p. 11.)

The linearity of Vuillard's design sets it apart from his subsequent programs, all of which exploit the tonal possibilities of the lithographic medium and are, in this sense, closer to his paintings of this period.

95. **Edouard Vuillard (1868–1940)**
Program for "An Enemy of the People," 1893
lithograph
Roger-Marx 17
9½ x 12⁹⁄₁₆ in. (241 x 319mm)
The Atlas Foundation

Lugné-Poë played the lead in the Théâtre de l'Oeuvre production of Ibsen's *An Enemy of the People* which opened November 8, 1893, and for which Vuillard created this program. The play, which concerns a doctor who discovers and announces that his town's lucrative mineral springs are polluted, was received with great applause for what audiences saw as its anarchist tendencies and its attacks against authority, politicians and journalists.

Cat. No. 96

Cat. No. 97

Cat. No. 98

96. Edouard Vuillard (1868–1940)
Program for "Ames Solitaire," 1893
lithograph
Roger-Marx 19
13 x 9⅟₁₆ in. (330 x 230mm)
The Atlas Foundation

This program for the December 13, 1893 production of Gerhart Hauptmann's *Ames Solitaires (Solitary Souls)* carries an advertisement for the "transformed" *Revue Blanche* scheduled to appear the following month. With the January, 1894, issue the *Revue Blanche* grew from 80 to 100 pages and the price was increased to one franc.

The play revolves around questions of faith and whether art should be sacrificed for action: the presence of a young girl causes dissension in a household, but when she agrees to leave the hero drowns himself.

97. Edouard Vuillard (1868–1940)
Program for "Au Dessus des Forces Humaines," 1894
lithograph
Roger-Marx 18
12⅞ x 18¾ in. (327 x 476mm)
The Atlas Foundation

For this Théâtre de l'Oeuvre production of part one of Bjornstjerne Bjornson's *Au Dessus des Forces Humaines (Beyond Human Strength)* (2/13/94) Vuillard created a two-part program. The right half of the sheet with the cast of characters bears a somber scene appropriate to the theme of the play. The left half is an advertisement with the exhortation "Read the *Revue Blanche*" superimposed three times on a representation of elegantly dressed women in an interior.

98. Edouard Vuillard (1868–1940)
Program for "Une Nuit d'Avril à Céos," 1894
lithograph
Roger-Marx 22, ⁱⁱ/ᵢᵢ
12¹³⁄₁₆ x 19 in. (325 x 483mm)
The Atlas Foundation

Une Nuit d'Avril à Céos by Gabriel Trarieux and *L'Image* by Maurice Beaubourg were Théâtre de l'Oeuvre productions that opened February 27, 1894. Lautrec depicted Lugné-Poë as one of the actors in this production of *L'Image* (cat. no. 33) whose author, Beaubourg, contributed several articles on literature and the theatre to the *Revue Blanche* over the course of the decade. Vuillard's program again features a *Revue Blanche* advertisement.

Cat. No. 99

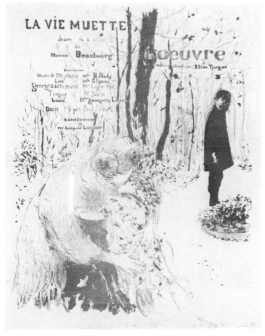

Cat. No. 100

99. Edouard Vuillard (1868–1940)
Program for "The Master Builder," 1894
lithograph
Roger-Marx 21, ii/ii
12¾ x 9½ in. (324 x 241mm)
The Atlas Foundation

Vuillard created this program for the April 3, 1894, Théâtre de l'Oeuvre production of Ibsen's *The Master Builder (Solness le Constructeur)*.

100. Edouard Vuillard (1868–1940)
Program for "La Vie Muette," 1894
lithograph
Roger-Marx 20
13 x 10 in. (330 x 254mm)
The Atlas Foundation

Maurice Beaubourg's *La Vie Muette* was produced by the Théâtre de l'Oeuvre on November 27, 1894. The psychological tension in Vuillard's design between the dark, distant male figure and the woman embracing her children in the foreground introduces a dramatic note unusual in the artist's work. It indicates that Vuillard took seriously the task of creating a design appropriate to the spirit of the play being produced. This bears out Lugné-Poë's remark that "Vuillard was the best of advisers, where the theatre was concerned, and one who dedicated himself to it wholeheartedly, from the first moment of its inception." (*Le Sot du tremplin,* quoted in Russell, *Vuillard,* p. 85.)

101. Edouard Vuillard (1868–1940)
Program for "Brothers," "The Guardian" and "Creditors," 1894
lithograph
Roger-Marx 23
18½ x 12¼ in. (470 x 310mm)
The Atlas Foundation

These three works by Herman Bang, Henri de Régnier and Auguste Strindberg were produced by the Théâtre de l'Oeuvre in 1894. Both Strindberg and Régnier contributed articles to the *Revue Blanche* and Vuillard's program design incorporates an advertisement for that publication.

The first play concerns two brothers in love with the same woman. The second, Régnier's symbolist work described as a poem, concerns a confrontation between the Master, returned from battles to the chateau where he had spent his childhood, and a female Guardian who is his soul. The title of Strindberg's play derives from its theme that men are always debtors to women who, though inferior, take advantage of men. The heroine of the play, yeilding to her ex-husband, causes the death of her sickly second husband whom the ex-husband had arranged to have listening in an adjacent room.

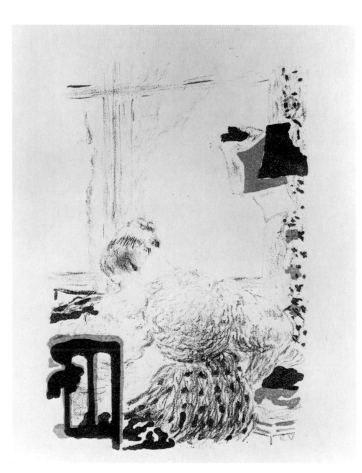

Cat. No. 103

102. **Edouard Vuillard (1868–1940)**
Prospectus Program for Théâtre de l'Oeuvre, 1895–96
lithograph
9¾ x 29 in. (248 x 737mm)
The Atlas Foundation

Six artists contributed prints to this special prospectus program announcing the Théâtre de l'Oeuvre 1895-96 season: Denis, De la Gandara, Doudelet, Toulouse-Lautrec, Vallotton and Vuillard. Also included in the exhibition are a rare early proof of Lautrec's lithograph (cat. no. 42) and another impression of the published program exhibited to show the Lautrec and Vallotton images (cat. no. 42a).

103. **Edouard Vuillard (1868–1940)**
The Dressmaker (La Courteriere), 1895
color lithograph
Roger-Marx 13
10 x 6½ in. (258 x 165mm)
The University of Michigan Museum of Art

When Vuillard was fifteen his father died and his mother established herself as a dressmaker to support her family, working in her apartment with two assistants. Thus, from adolescence onward Vuillard was surrounded by women like the young seamstress seen here bent over her work.

104. **Edouard Vuillard (1868–1940)**
Program for "The Pillars of Society," 1896
lithograph
Roger-Marx 24, $^{iii}/_{iii}$
15 x 22¼ in. (381 x 565mm)
The Atlas Foundation

Ibsen's *Pillars of Society (Les Soutiens de la Société)* was produced by Lugné-Poë's Théâtre de l'Oeuvre on June 16, 1896. The play concerns a lawyer, a defender of morality, who blames his brother-in-law for a crime that he, himself, has committed.

Cat. No. 105

105. **Edouard Vuillard (1868–1940)**
Program for "Au Dela des Forces Humaines," 1897
lithograph
Roger-Marx 25, $^{ii}/_{ii}$
9½ x 12½ in. (241 x 318mm)
The Atlas Foundation

For this program for part two of Bjornson's *Beyond Human Strength,* produced by the Théâtre de l'Oeuvre, January 26, 1897, Vuillard has manipulated the lithographic process in a variety of unusual ways, including scraping the stone to create white highlights. The contrast with his early program for *Rosmersholm* (cat. no. 93), which simply reproduced a line drawing, is remarkable.

The play concerns labor unrest among a group of miners. One pastor counsels resignation; another preaches revolt. When the miners strike the heroine goes as a maid into a castle where the industrialists are meeting. The castle is dynamited; she is killed and the industrialists are injured, but the play ends on a hopeful note.

106. **Edouard Vuillard (1868–1940)**
The Two Sisters-in-law (les deux belles-soeurs), 1899
color lithograph from *Paysages et intérieurs*
Roger-Marx 43
14 x 11 in. (355 x 280mm)
Lent by Professors Alice and George Benston,
University of Rochester

The two women depicted here are Misia Natanson and her sister-in-law, the actress Marthe Mellot. A singer celebrated for her beauty, as well as an actress, Mellot appeared in numerous theatrical productions including Edouard Dujardin's symbolist drama *Antonia*. Toulouse-Lautrec also depicted her several times. It was reportedly through Vuillard that Marthe Mellot met her future husband, Alfred Natanson.

This print is from a portfolio of twelve color-lithographs by Vuillard published by the art dealer Ambroise Vollard in 1899 under the title *Landscapes and Interiors (Paysages et intérieurs*).

107. **Edouard Vuillard (1868–1940)**
Pink Interior I (Interior aus tentures roses), 1899
color lithograph from *Paysages et intérieurs*
Roger-Marx 36
13⅜ x 10⅝ in. (340 x 270mm)
The University of Michigan Museum of Art

In Vuillard's three related prints—*Pink Interior* I, II and III, the room itself, with its patterned pink wallpaper, becomes the main subject. Human figures are glimpsed through open doorways. The pink room is empty.

The stillness of Vuillard's imagery brings to mind André Gide's comment: "M. Vuillard speaks almost in a whisper—as is only right, when confidences are being exchanged—and we have to bend over toward him to hear what he says." (*Gazette des Beaux-Arts,* Dec. 1, 1905, translated in Russell, *Vuillard,* p. 96.)

108. **Edouard Vuillard (1868–1940)**
Pink Interior III (Interior aux tentures roses III), 1899
color lithograph from *Paysages et intérieurs*
Roger-Marx 38
13⅜ x 10⅝ in. (340 x 270mm)
The University of Michigan Museum of Art

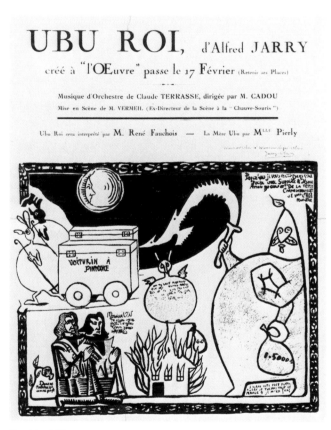

Cat. No. 110

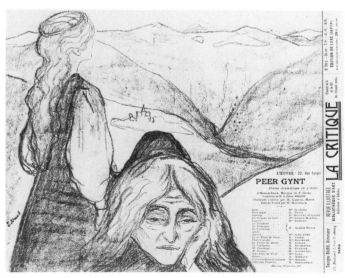

Cat. No. 112

109. **Edouard Vuillard (1868–1940)**
Une Répétition a l'Oeuvre, 1903
lithograph
Roger-Marx 50, ⁱᵛ/ᵢᵥ
12¼ x 8¼ in. (311 x 210mm)
The Atlas Foundation

Vuillard's depiction of a rehearsal at the Théâtre de l'Oeuvre was used as a program for *l'Oasis* by Jean Juillen in December of 1903, the year in which the *Revue Blanche* ceased publication. This was Vuillard's last theatre program.

110. **Alfred Jarry (1873–1907)**
Program for "Ubu Roi," 1897
12¾ x 9⅞ in. (324 x 251mm)
The Atlas Foundation

Alfred Jarry's scatological play *Ubu Roi* enjoyed a *succèss de scandale* on opening night December 10, 1896. Although Jarry himself created this program, Bonnard designed the sets and Vuillard, Lautrec, Sérusier and Paul Ranson helped paint them. Music was composed by Bonnard's brother-in-law Claude Terrasse.

> . . . the scenery was painted to represent, by a child's conventions, indoors and out of doors, and even the torrid, temperate and arctic zones at once. Opposite you, at the back of the stage, you saw apple trees in bloom, under a blue sky, and against the sky a small closed window and a fireplace . . . through the very midst of which . . . trooped in and out the clamorous and sanguinary persons of the drama. (Arthur Symons, *Studies in Seven Arts,* quoted in Shattuck, *The Banquet Years,* p. 207.)

Pérc Ubu's first line, "*Merdre!,* " (Shite!) created pandemonium in the theatre. Later Jarry wrote in the *Revue Blanche*:

> It would have been easy to alter *Ubu* to suit the taste of the Paris public by making the following minor changes: the initial word would have been "Blast" . . ., the lavatory brush would have been a courtesan's couch, Ubu would have conferred a knighthood on the Tsar, and several people would have committed adultery—but then it would have been filthier. ("Questions de théâtre," *La Revue Blanche,* January 1, 1897, p. 16.)

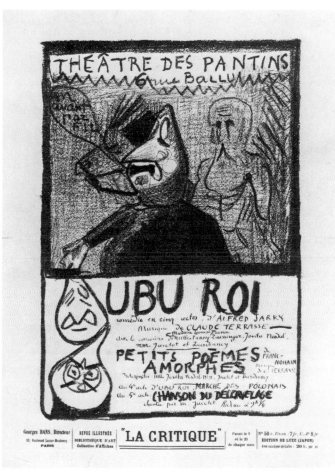

Cat. No. 111

111. Alfred Jarry (1873–1907)
Program for "Ubu Roi," c. 1898
14¼ x 10⅜ in. (362 x 264mm)
The Atlas Foundation

This program for *Ubu Roi* was designed by the author Alfred Jarry for a production at the Théâtre des Pantins, a puppet theatre created by Jarry, the poet Franc Nohain and the composer Claude Terrasse (Bonnard's brother-in-law). All three were *Revue Blanche* contributors.

A writer for the *Echo de Paris* described the theatre in April, 1898:

> Rue Ballu, at the back of a courtyard, on the first floor, a mini-theatre for a tiny audience. It is here that Alfred Jarry, with the aid of some ingenious marionettes, has recently staged a revival . . . of his epic *Ubu*. The auditorium is cramped but is pleasantly decorated by Edouard Vuillard with pyrotechnics of dazzling colour, and by Bonnard with some quite beautifully executed silhouettes in black and grey. (Quoted in Bouvet, *Bonnard,* p. 59.)

112. Edvard Munch (1863–1944)
Program for "Peer Gynt," 1896
lithograph
Schiefler 74b
9¹¹⁄₁₆ x 12¼ in. (246 x 311mm)
The Atlas Foundation

The Norwegian artist Munch created this program for the November 12, 1896 Théâtre de l'Oeuvre production of *Peer Gynt* by his fellow countryman, Henrik Ibsen. The play concerns the travels and strange adventures of Peer Gynt, a rogue deemed unworthy even of Hell, but who in the end is saved by Solveig who had waited for him because he was her faith, hope and love.

In 1894, Thadée and Misia Natanson and Lugné-Poë, whose Théâtre de l'Oeuvre had opened the previous year with a production of Ibsen's *Rosmersholm,* traveled to Norway to meet the playwright.

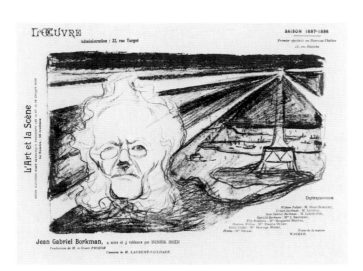

Cat. No. 113

113. **Edvard Munch (1863–1944)**
Program for "Jean Gabriel Borkman," 1897
lithograph
Schiefler 171a
11⅛ x 15 in. (283 x 381mm)
The Atlas Foundation

Vallotton's woodcut portrait of Ibsen (cat. no. 42a) seems to have served as the model for the portrait incorporated by Edvard Munch into this program for the November 9, 1897, Théâtre de l'Oeuvre production of Ibsen's *Jean Gabriel Borkman.* The play dealt with family quarrels and the possibility of rehabilitation after crime.

114. **Paul Signac (1863–1935)**
D'Eugene Delacroix au Neo-Impressionisme, 1899
book
From the collection of Mr. and Mrs. Herbert D. Schimmel

In addition to this historical essay published by the *Revue Blanche* in 1899, the painter Paul Signac contributed several articles which appeared in the review itself between 1898 and 1902. Signac was closely associated with the painter Georges Seurat whose work was championed by the review's editorial secretary Félix Fénéon.

115. **Paul Signac (1863–1935)**
Program for Théâtre Libre
color lithograph
6¼ x 7¼ in. (160 x 186mm)
Private Collection, New York

Signac demonstrates here an application of scientist Charles Henry's color theories. The program was for the December 10, 1888 productions of *La Chance de Françoise* by Léon Hennique, *La Mort du Duc D'Enghien* by George de Porto-Riche, and *Le Cor Fleuri* by Ephraim Mikhael.

Cat. No. 114

SELECTED BIBLIOGRAPHY

Bouvet, Francis. *Bonnard: The Complete Graphic Works.* Translated by Jane Brenton. Introduction by Antoine Terrasse. New York: Rizzoli, 1981.

Chassé, Charles. *The Nabis & their Period.* Translated by Michael Bullock. New York: Frederick A. Praeger, 1969.

Chastel, André. *Vuillard: 1868–1940.* Paris: Floury, 1946.

Cooper, Douglas. *Henri de Toulouse-Lautrec.* New York: Harry N. Abrams, Inc., 1956.

Dauberville, Jean and Dauberville, Henry. *Bonnard: Catalogue raisonné de l'oeuvre peint, 1888–1905.* Paris: Editions J. et H. Bernheim-Jeune, 1965.

Delteil, Loys. *Le Peintre-Graveur Illustré,* vols. 10 and 11: *H. de Toulouse-Lautrec.* Paris: Chez l'Auteur, 1920; New York: Collectors Editions Ltd. and Da Capo Press, 1968.

Dortu, M. G. *Toulouse-Lautrec et son oeuvre.* 6 vols. New York: Collectors Editions Ltd., 1971.

Ferminger, André. *Pierre Bonnard.* New York: Harry N. Abrams, Inc., n.d.

Gold, Arthur and Fizdale, Robert. *Misia: The Life of Misia Sert.* New York: Alfred A. Knopf, Inc., 1980; also New York: Morrow Quill Paperbacks, 1981.

Goldschmidt, Lucien and Schimmel, Herbert, eds. *Unpublished Correspondence of Henri de Toulouse-Lautrec.* London: Phaidon Press Ltd., 1969.

Guisan, Gilbert and Jakubec, Doris, eds. *Félix Vallotton. Documents pour une biographie et pour l'histoire d'une oeuvre.* Vol. I: *Lettres 1884–1899.* Lausanne-Paris: La Bibliothèque des Arts, 1973.

Henderson, John. *The First Avant-Garde 1887–1894: Sources of the Modern French Theatre.* London: Harrop, 1971.

Hermann, Fritz. *Die Revue Blanche und die Nabis.* Munich: 1959.

Jackson, J. B. *La Revue Blanche (1884–1903): Origine, influence, bibliographie.* Paris: Lettres Modernes, 1960.

Jasper, Gertrude R. *Adventure in the Theatre: Lugné-Poë and the Théâtre de l'Oeuvre to 1899.* New Brunswick, N.H.: Rutgers University Press, 1947.

Jourdain, Francis and Adhémar, Jean. *T-Lautrec.* n.p.: Éditions Pierre Tisné, 1952.

Lugné-Poë, Aurélien. *La Parade. II. Acrobaties, souvenirs et impressions du théâtre, 1894–1902.* Paris: Nouvelle Revue Française, 1931.

Mondor, Henri. *Vie de Mallarmé.* Paris: Gallimard, 1941.

Natanson, Thadée. *Peints à leur tour.* Paris: Albin Michel, 1948.

Preston, Edouard. *Edouard Vuillard.* New York: Harry N. Abrams, Inc., n.d.

Rewald, John. *Pierre Bonnard.* New York: The Museum of Modern Art, 1948.

_____. *Post-Impressionism from Van Gogh to Gauguin.* New York: The Museum of Modern Art, 1956, revised, 1962.

Ritchie, Andrew Carnduff. *Edouard Vuillard.* New York: The Museum of Modern Art, 1954.

Robichez, Jacques. *Le Symbolisme au Théâtre: Lugné-Poë et les débuts de l'Oeuvre.* Paris: L'Arche, 1957.

Roger-Marx, Claude. *Vuillard: His Life and Work.* Translated by E. B. D'Auvergne. New York: Editions de la Maison Française, 1946.

_____. *L'Oeuvre gravé de Vuillard.* Monte Carlo: A. Sauret, 1948.

Russell, John. *Edouard Vuillard 1868–1940:* Toronto: Art Gallery of Ontario, 1971.

St. James, Ashley. *Vallotton graveur.* Translated by Françoise Sotelo. Paris: Sté Nlle des edition du Chêne, 1979.

Salomon, Jacques. *Vuillard.* Paris: Gallimard, 1968.

Sert, Misia. *Misia and the Muses.* New York: John Day, 1953.

Shattuck, Roger. *The Banquet Years: The Arts in France 1885–1918, Alfred Jarry, Henri Rousseau, Erik Satie, Guillaume Apollinaire.* Garden City, N.Y.: Doubleday, 1961.

Soby, James Thrall; Elliott, James; and Wheeler, Monroe. *Bonnard and his Environment.* New York: The Museum of Modern Art, 1964.

Stevens, Mary Anne, and St. James, Ashley. *The Graphic Work of Félix Vallotton 1865–1925.* London: Arts Council of Great Britain, 1976.

Stuckey, Charles F. and Maurer, Naomi E. *Toulouse-Lautrec: Paintings.* Chicago: The Art Institute of Chicago, 1979.

Terrasse, Antoine. *Pierre Bonnard.* Paris: Editions Gallimard, 1967.

The University of Kansas Museum of Art. *Les Mardis: Stéphane Mallarmé and the Artists of his Circle.* Lawrence, Kansas: The University of Kansas Museum of Art, 1965.

Vallotton, Maxime and Goerg, Charles. *Félix Vallotton: Catalogue raisonné de l'oeuvre gravé et lithographié.* Geneva. Bonvent, 1972.

Cat. No. 42a